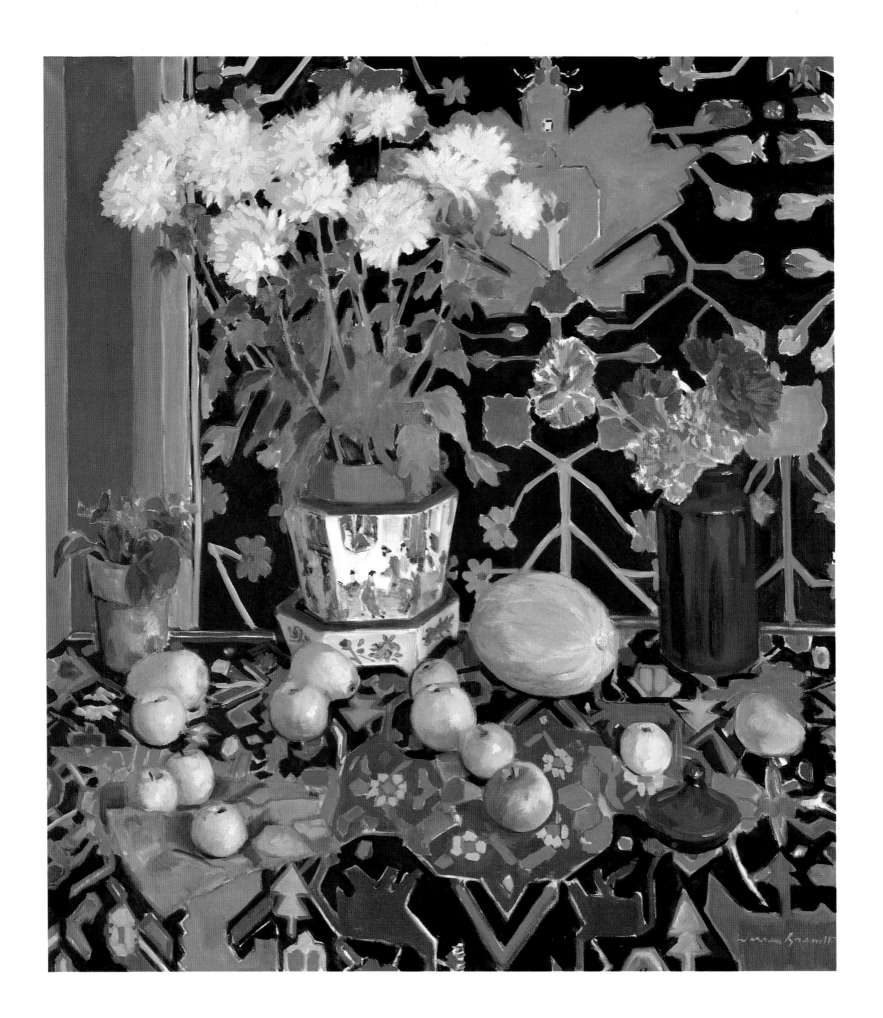

NICHOLAS FOX WEBER

WARREN BRANDT

HUDSON HILLS PRESS, NEW YORK

FOR *Kay Swift*

Frontispiece
Still Life with Mums and Carnations
1972
oil on canvas
40 x 36 inches
Collection: Mr. and Mrs. Leon Black,
New York, N.Y.

FIRST EDITION

© 1988 by Warren Brandt
Text © 1988 by Nicholas Fox Weber

All rights reserved under International and Pan-American Copyright Conventions.
Published in the United States by Hudson Hills Press, Inc., Suite 1308, 230 Fifth Avenue, New York, NY 10001-7704.

Distributed in the United States, its territories and possessions, Mexico, and Central and South America by Rizzoli International Publications, Inc.

Distributed in the United Kingdom, Eire, Europe, Israel, and the Middle East by Phaidon Press Limited.

Distributed in Australia by Bookwise International.

Distributed in New Zealand by Roulston Greene Publishing Associates Ltd.

Distributed in Japan by Yohan (Western Publications Distribution Agency).

Distributed in South Korea by Nippon Shuppan Hanbai.

Editor and Publisher: PAUL ANBINDER

Copy editor: JACQUELINE DECTER

Indexer: GISELA S. KNIGHT

Designer: NAI CHANG

Composition: U.S. LITHOGRAPH, TYPOGRAPHERS

Manufactured in Japan by Toppan Printing Company

Library of Congress Cataloguing-in-Publication Data

Weber, Nicholas Fox, 1947–
 Warren Brandt.

 Bibliography: p.
 Includes index.
 1. Brandt, Warren, 1918– . Criticism and interpretation. 2. Painting, American. 3. Painting, Modern—20th century—United States. I. Brandt, Warren, 1918– . II. Title.
ND237.B794W4 1988 759.13 87-32372
ISBN 0-933920-98-9

CONTENTS

List of Illustrations

Works marked with an asterisk (*) are reproduced in color

WARREN BRANDT

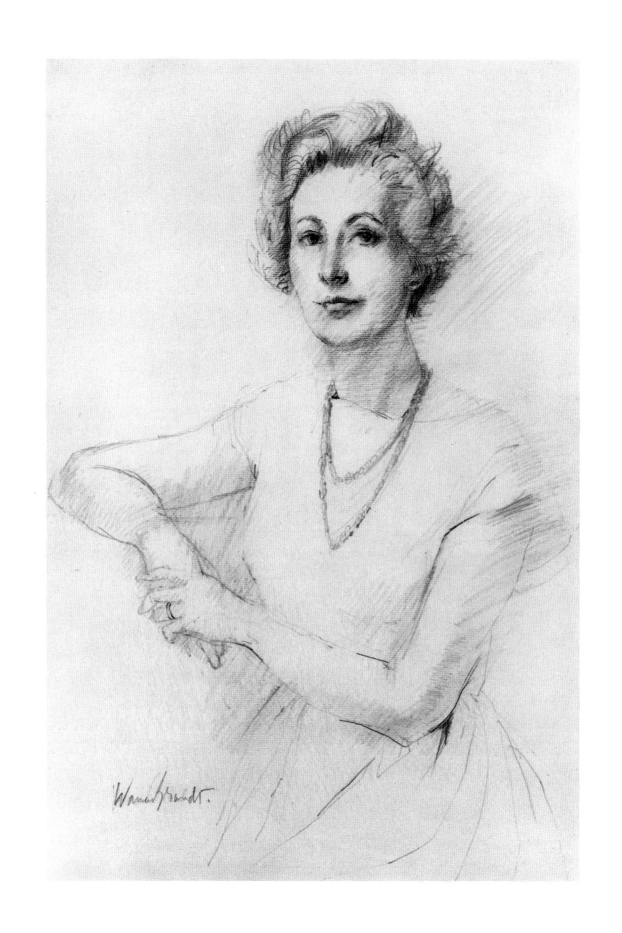

Preface and Acknowledgments

Trends in art come and go speedily, but have a powerful grip. A public ever eager for "the latest" gives them vast say, and scores of artists everywhere follow their dictates.

Fortunately there are other voices. Warren Brandt is among the serious artists at work today who are impervious to all the "ins" and "outs." The frequent conversations I had with him in his studios in 1985 and 1986—and which are the source of all the quotations in this book (unless otherwise identified)—have brought me close to values in painting that strike me as utterly essential, and timeless. Brandt has a profound sense of the beauty of things and of the solid craftsmanship that is a means to that beauty. I thank him for his directness and clarity in sharing his methods and passions, and for his constant graciousness.

My deep appreciation also goes to Warren Brandt's wife, Grace Borgenicht Brandt, for all of her helpfulness and meticulous attention to detail ever since this project began. I am also grateful to the various collectors about whose paintings I have written; the staff of the Fischbach Gallery; Judd Tully; Martin Ackerman, for his suggestion that I write on Brandt; Paul Anbinder, of Hudson Hills Press, for his tremendous eye and ear; and, above all, my wife Katharine. As for the great lady to whom this book is dedicated (and who is my wife's grandmother), she has much in common with Warren Brandt's paintings. Quality pervades. Kay Swift is not only always a pleasure to look at, but also endlessly vibrant and giving: the ultimate class act.

N.F.W.
Bethany, Connecticut
July 1987

Portrait of Grace
1961
pencil
12 x 9 inches

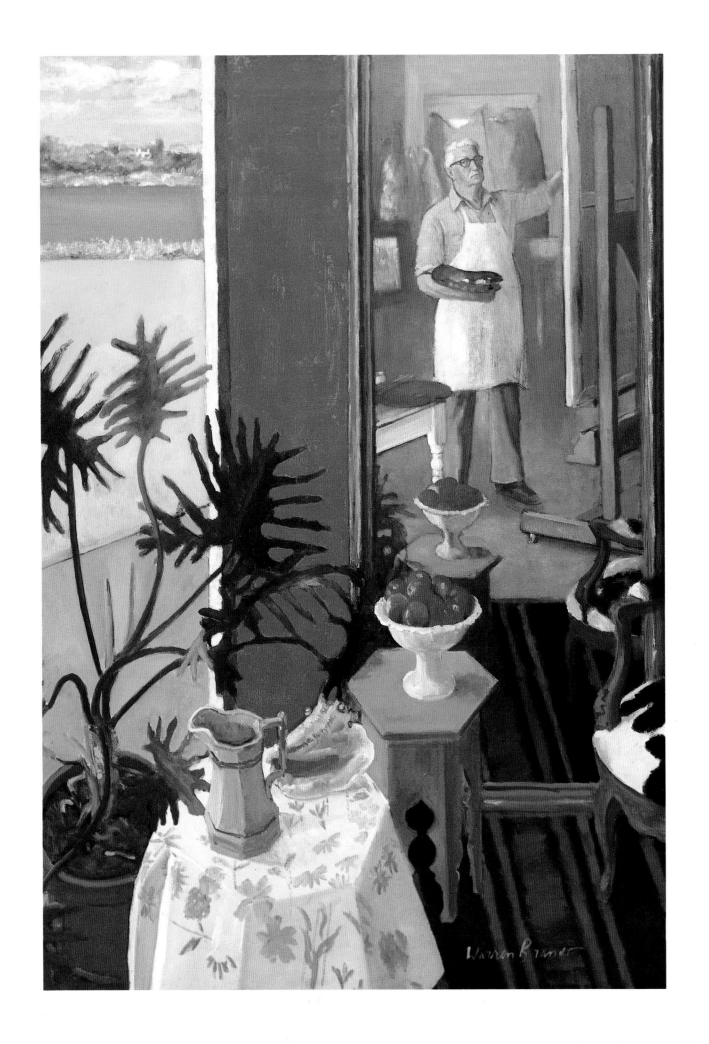

In the summer of 1985 a self-portrait by Warren Brandt hung in an exhibition at the National Academy of Design in New York. The show—*The Figure in Twentieth-Century American Art*—consisted of works from the collection of the Metropolitan Museum of Art. There were paintings by artists as diverse as Edward Hopper and Jules Pascin, Willem de Kooning and Norman Rockwell, Jackson Pollock and Andrew Wyeth. Brandt's self-portrait, *The Artist in His Studio* (page 10), had something very distinctive about it. It was warmer than most of the other works, easier to be with, more welcoming. It had a softness to it, but by no means a fuzziness; rather, a gentle quality achieved with the utmost clarity. One felt immediately what a pleasure it must have been to paint this picture. There is the large open window letting in an ample light and a glimpse of the shoreline of eastern Long Island. A conch shell, a flowered tablecloth, an antique pitcher, a bowl full of fruit, a Louis XV armchair covered with pony skin—the objects all bespeak comfort and well-being: domestic luxury, plenitude, enjoyment in daily living. A philodendron plant thrives in the foreground, and it flourishes in two ways: as a plant, which it most successfully is, and as a piece of painting, arranged with an eye for constant rhythm and the play of abstract forms.

Warren Brandt is reflected in a large mirror leaning against the wall. He is standing at an easel at some distance from the scene before us. But the man himself is just a small part of things. This self-portrait dwells neither on his body nor on the details of his face or its expression. In fact it is the entire canvas, in its serenity and hard-fought ease, that reveals his soul. The omnipresent sense of the luxury of objects, as of forms and colors, is the very fiber of Warren Brandt's being. The mastery of craft that enabled him to articulate all the spaces and the angles of the reflection, and at the same time to come up with a lively and artful composition, is both his motive and his essence. The shadows on the hexagonal top of a Moorish table—paeans to light, true reflections of the appearance of things—bring us face to face with the inner nature of Warren Brandt.

One knows from this self-portrait that Brandt willingly takes on tough tasks. He deliberately challenged himself by positioning the objects in front of a view that combines a full-length mirror with a picture window. He risked many surfaces: pony skin, carpet, wood, cloth, ceramic, seashell, glass. And, through suggestion rather than imitation, he caught them all, so that we have no doubt as to what they are. He varied his forms—big, gentle circular sweeps; sharp, staccato curves; straight horizontals, verticals, and diagonals—while always keeping the broad rhythms and the overall structure.

The Artist in His Studio
1979
oil on canvas
64 x 45 inches
Collection: Metropolitan Museum of Art,
New York, N.Y. Purchase:
Eric W. Goldman, 1980

Brandt, as we see him in this painting, is separated from the overall configuration by more than physical space; he is the one stern note in the painting. The figure has an entirely different voice from the rest of the work. We feel his seriousness. He is hard at work, and it has been a long labor. The world he presents is an assemblage of sources of relaxation, of an all-encompassing sense of comfort. But our glimpse of its creator reminds us that all that grace comes only with prodigious effort.

More than many other painters today, but very much in keeping with his heroes of the past, Brandt composes—surely and deftly, with a total focus on the present but a knowledge of the lessons of the past. First there is the big plan, the strong horizontal-vertical grid, penetrated from all directions with a variety of lively diagonals. There is the very deliberate combination of flatness and depth: a complex network of distinctly legible planes. Then there are all the curves: ovoid, bulging, at times meandering. Color is used as unequivocally as form, not only locating things in space but also enriching the mixture of elements. It has all been thought out very carefully and intelligently. The act of painting is intense, the results sumptuous.

To talk with Warren Brandt is to spend time with someone who has the rare quality of being completely at ease with himself and the world around him. He in no way typifies the struggling artist. Although painting is an ongoing struggle for him, it is a struggle he loves, a deeply felt pursuit more than a torture. Brandt has that passionate sense of pleasure of a salmon fisherman who wades the stream patiently for days on end, trying this fly or that stretch of water, always enjoying the setting and the act, whatever the result may be.

Brandt speaks slowly and precisely in a gently modulating voice. He has a slight drawl that suggests his North Carolina origins. Modest and unassuming, he sprinkles his conversations with statements like "I don't know if you're interested in all this" and "I don't mind being influenced." He often follows discussions of his likes and dislikes in art with a soft-toned "Do you agree with me there?" He is a large man—somewhat larger than he appears in the self-portrait—and is inclined to sit back in a rocking chair that he fills up rather completely. Looking at him in his house or studio on Long Island or in his apartment or studio in Manhattan, we picture him on a southern veranda. We feel comfortable in his presence in the same way that we feel soothed by a balmy southern evening.

He wants to make everything nice. He wants us to feel good. He can describe periods in his life that would sound torturous from the mouths of others—a sick wife, no money, impending divorce—but what is salient for him are the good moments: his first wife's abilities as a poet; the museums he visited; the time he got to spend on his own painting. His approach to life is like his approach to art: he has chosen, deliberately and intelligently, to focus on the better elements—never ignoring the other side of things, just cognizant of his

preferences. In personality he is a bit like a wise high-school history teacher or a southern chef who reveres old recipes, has learned the necessary skills, and savors a sense of well-being.

His abiding wish at the age of sixty-nine is to have more time to paint; that has always been his quest. He does his best to get to his studio early every morning, driving the few blocks from his home in Water Mill or taking the bus in New York City, but the practical side of life sometimes gets in his way. These days the interruptions are visits from collectors, doctor's appointments, and the like—he bemoans the time wasted. In the old days the problem was the need to make money.

At the beginning of his career Brandt thought that he would have to be an illustrator in order to make ends meet. Born in Greensboro, North Carolina, in 1918, he knew he wanted to be an artist by age thirteen, when, on a visit to relatives in New York, he began to do drawings from plaster casts at the Metropolitan Museum of Art. He kept on drawing right through high school and the day after graduation returned to New York with seven dollars in his pocket "to become an artist." He attended night school at the Pratt Institute, where he studied illustration, supporting himself on the twelve dollars a week he earned delivering mail for the Allied Purchasing Corporation in the garment district. For the first seven months he lived in a YMCA until his mother came up from North Carolina to help him out. A resourceful woman, she bought furniture from Goodwill Industries, opened a boarding house in Brooklyn not far from the school, and saw to it that her son was well housed and fed until she felt that he could manage on his own. In 1938, when he was twenty years old, Brandt hitchhiked to California, where he spent a year doing animation for Walt Disney, after which he returned to New York to try to make it as a painter once again.

He resumed his studies at Pratt for a short time and then went off on his own to work for an artist who had a studio at 51 West Tenth Street. He remembers the place fondly. "It was one of the great studio buildings in New York for at least a hundred years. The center studio, which had been the famous workplace of William Merritt Chase, was four stories high with skylights on top. There were adjacent studios around that central core on the second, third, and fourth floors. The studio I worked in as an apprentice was on the top floor of the south side and had a north skylight."

Although he would later return to the same building, Brandt did not stay there for long that first time. Aware of what was going on in Europe in 1940, he joined the French volunteer ambulance corps. But the week that he was supposed to go abroad, France fell. Eager to do whatever he could to help halt Hitler, he then joined the National Guard back in North Carolina. This was the beginning of a five-and-one-half-year stint with the military. Brandt's commitment to the Allied cause was a passionate one, in spite of what it meant at this vital point in his growth as an artist.

He did not stop painting completely, however; in North Carolina he got himself a job on the army newspaper sketching a different sergeant each week. And he found that by agreeing to do a portrait of a general he could gain admittance to Officer's Candidate School for the Air Force. But after completing OCS, he decided to return to army camp in Greensboro, where he rejoined his girlfriend and married her.

For the first five years after the war, Brandt was on the GI bill. He and his wife, Carolyn, first moved to New York and he again found studio space in the building on West Tenth Street, where he was blessed with low rent and a large, well-lit space. Carolyn worked as an editor, and Warren studied at the Art Students League with Yasuo Kuniyoshi. A 1946 nude (page 15), clearly a by-product of his work with Kuniyoshi, lacks the sensuousness and flow that would eventually characterize his work, but it does reveal an impressive level of competence and craftsmanship. We sense Brandt's response to some of the lessons of Renoir in the plasticity and the allure with which flesh is rendered. It is an exploratory painting, but the enthusiasm and sureness of the exploration are apparent. He painted it during a time that was particularly eye-opening for him; in 1946 there was suddenly a lot of new art to see in New York, and the young artist at school on Fifty-seventh Street found the galleries full of great work, including some paintings by Matisse that were revelatory for him.

But because of the GI bill, the lure of travel was irresistible. The Brandts left New York after less than a year and spent seven months in Mexico. From there they went to Washington University in St. Louis, where Carolyn taught freshman English and Warren studied art with Philip Guston. Brandt finished his undergraduate work in a year and a half, earning his degree summa cum laude.

Philip Guston got a Guggenheim Fellowship and asked Brandt's advice about who should replace him. Brandt, who was then thirty, suggested Max Beckmann. He had seen Beckmann's work in a show at the Curt Valentin Gallery in New York and it had moved him greatly. Almost all of the literature on Brandt—and the list of exhibition catalogues and reviews is long—stresses his link to Beckmann. Brandt's admiration for Beckmann's work was the pivotal factor in bringing the renowned German Expressionist from Holland to the United States, but the connection between Brandt's and Beckmann's art is harder to discern. Beckmann's complex subject matter is often allegorical and generally discomfiting, the tone of his colors and lines highly strident. Brandt was able to learn a great deal from him nevertheless. "The one thing he taught was organization. The big rhythm that goes through a painting is the main organizing factor. When I start a picture, I do it in the same way; I use charcoal and make large rhythmical strokes to get the main division of space on the canvas and establish its order."

Brandt's work of that time shows that strong sense of organization. In *Gymnast* (page 16), a 1948 oil, the torso of the acrobat holds the stage impressively, his body and robe a sequence of carefully related curves. In the bold black lines and highly charged tones of the painting, the importance of Beckmann is evident. But there is less torture, and less symbolism, than in most of Beckmann's work. The lesson Brandt has most surely gleaned from the great German Expressionist is that of boldness, a sort of painterly self-confidence. Although his sensibility differed greatly from that of his teacher, that lesson would serve him well in the years to come.

Brandt tells a story about Beckmann that illustrates the effect his mentor had on him. Shortly after Beckmann arrived in St. Louis, Brandt showed him a painting he had done very much in the German's style. Beckmann asked Brandt for a big brush and some black paint and then simply added six big strokes to the painting. "The whole thing came

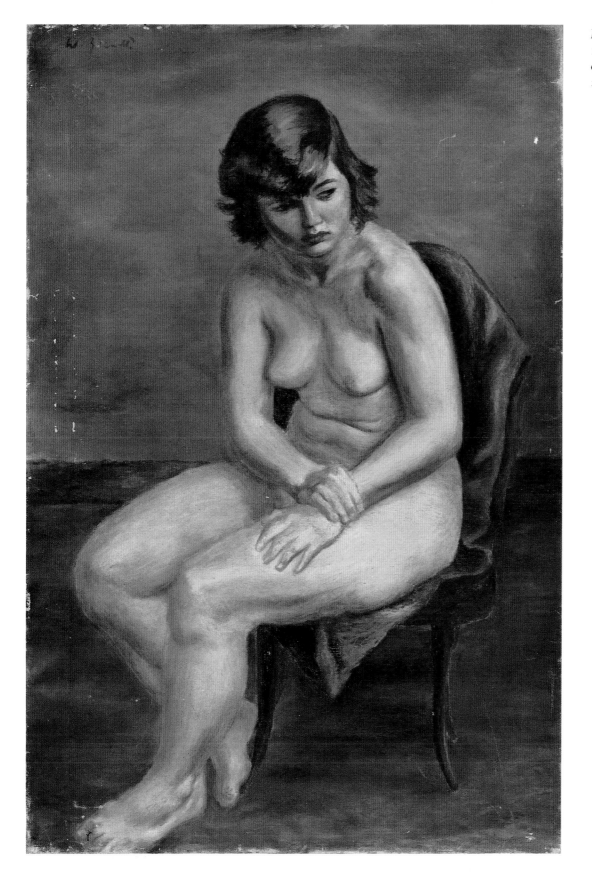

Nude
1946
oil on canvas
29 x 20 inches

Gymnast
1948
oil on canvas
38½ x 25½ inches

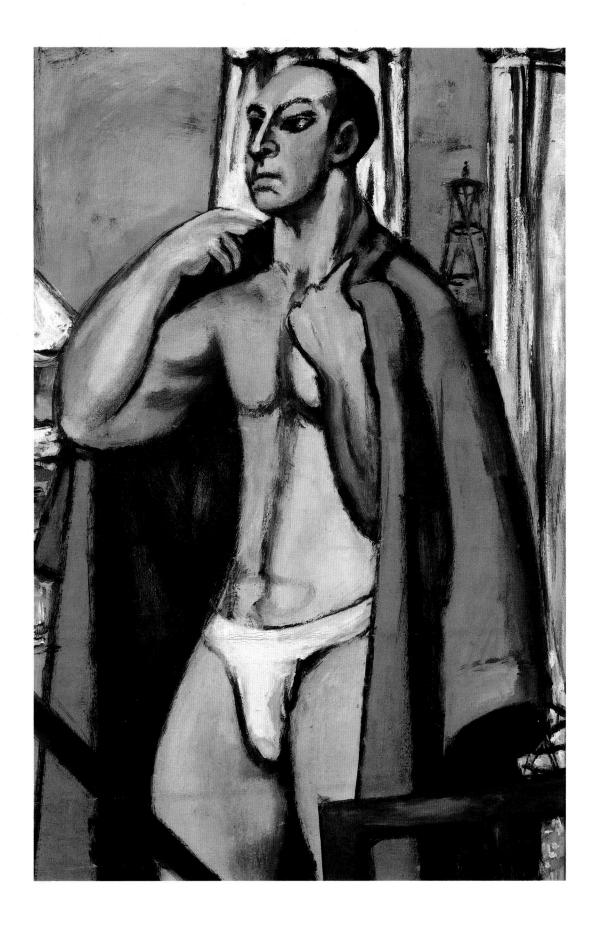

together. I learned then the degree to which it is the broad rhythms that matter. Degas worked thin, and Manet worked heavy, but they both have those rhythms, and that organization, that make beautiful paintings."

Aside from Beckmann, there were other artists—Europeans more so than Americans —whose work affected Brandt profoundly. On a train trip between New York and St. Louis in 1947, he was moved to tears when he read that Pierre Bonnard—whose work he knew from the Museum of Modern Art—had died. In 1948 he received a Milliken Fellowship from Washington University that enabled him and his wife to spend three months in Rome and seven in Paris. The miracles that were revealed to him in the museums abroad continue to inform his work, and conversation, today. The ability of earlier painters to evoke appearances, their clarity and sense of composition, gave him both vast pleasure and a better idea of his own goals. The artists Brandt discovered during that year have never failed him. "Titian is fabulous. Of all the Venetians, he's my man. Really, the papa of us all. It's like magic, simple but perfect. . . . Rembrandt also has that quality. His paintings have life in them; they're real. They're built up so richly. The paint works in mysterious ways—it looks as if it's all done in one sitting, wet into wet, but you know it really isn't." Brandt has studied these artists continuously, in books as well as museums. Most recently, he spent three weeks in European museums in 1984 just to focus on the old masters, and found that Titian, Rembrandt, Rubens, the seventeenth-century Dutch painters, Chardin, Corot, Degas, Manet, Monet, and the like seemed no less miraculous to him. He has always had a painter's approach to the art of the past, caring more for the qualities that link masters from different eras and locations than for art-historical categories: "There's no reason why you can't look at everybody; greatness has nothing to do with one era or one 'style.'"

When he talks of his heroes and their art, it is not ideas that are on his mind, but rather their mastery of the craft. He speaks of Rubens's use of turpentine, of Bonnard's idea of "surrendering to the picture," of the need for knowing the right technique so that one can meet "the demands of the picture." It is that love of putting paint on canvas, of getting the oils to perform a certain way, of achieving the broad pictorial rhythms and at the same time getting an apple to be an apple, of trying for success and acknowledging its absence when a picture "isn't yet there," that keeps Warren Brandt painting, looking, trying, and seeing all day long.

The eye for simplicity, composition, and rhythm is nowhere more apparent than in Brandt's recent views of interiors like the 1979 *Tulips, Lilacs, and Dogwood* (page 75). His work of the past few years is more sharply focused, more true in its rendering of the actual appearance of things, of surfaces and solidity, than ever before. And the notion of structure has become increasingly important; more than ever there is a system of scaffolding that holds

us in place, that makes the viewer feel he is being offered tangible support and order. The crisscross diagonals converge on the upper center of the composition and lead us to the lower right-hand corner of the matted painting hanging on the wall. Here we have art clearly drawing our attention to art. Stability—visual and therefore emotional—is Brandt's aim, and this deliberate focus on the idea of art is a perfect means of achieving it. The painted canvas affords one of the great opportunities to create stability through visual structure and through the many aspects of the selective process involved: choice of subject matter, color, juxtapositions, and balances. Brandt achieves both solidity and a tremendous quality of reassurance by the clarity of his response to, and reproduction of, the life before his eyes.

Looking at this painting, he won't admit his own achievement, but he will acknowledge his purpose. "What I admire in Manet is the idea of going in every direction but being held in place by a rigid form. There's all sorts of action, but it's in a gridwork that doesn't move. There's an equilibrium, and it's beautifully painted."

His constantly intensifying desire to grip reality and to organize the canvas may in part be a response to the current artistic scene. "I keep moving from realism to more realism. It's in part a reaction to all the nonsense out there. The more they paint loose, the more I want to paint what's real quality. I don't mean loose exactly—I like loose painting—I mean quick painting." He names some of the current superstars and diagnoses their gimmicks. "All they care about is being up-to-date, fashionable. They all get their little ideas. Art today is stylish, rather than having style, and there's a big difference. . . . And so many of the successful ones have such an ambitious quality. I just cannot be ambitious, other than in response to my own goals. I just want to be free to do the things I want to do. It's not that I don't want to be successful; I just want to be an artist." Brandt's criticism is never a diatribe; he voices his criticism of others and of current trendiness only after one has gotten to know him quite well. He is too calmly confident, too focused on his own aspirations, to explode. But he knows his own tastes, which conform to none of the bandwagons of the 1980s, and he takes on the latest movements with quiet authority, generally concluding with a gentle "Do you agree with me there?"

That quest to understand and convey something of universal beauty has of course been intrinsic to the aging process since the dawn of mankind. The drive is away from the extraordinary or merely different toward the power of everyday sights. We try and try to cultivate our articulation. So Rembrandt grew less specific in his emphasis on his subject and more exacting in the rendering. "It is when he starts depersonalizing his models, when he prunes objects of all identifiable characteristics, that he gives them the most weight, the greatest reality," Jean Genêt has said.* So King Lear, dethroned, stripped of every trapping, clung in monosyllables to the presence of the loyal Cordelia. So Cézanne pushed away at the idea of the mountain and the painted canvas. And Brandt wants those leaves to be leaves, and the confluence of diagonals and the balance of hues to be reassuring, heartening, steadying.

*Jean Genêt, "Something Which Seemed to Resemble Decay," translated by Bernard Frechtman, *Antaeus*, No. 54, Spring 1985, p. 116.

In 1949, after returning from abroad, Brandt accepted a job as chairman of the art department of Salem College in Winston-Salem, North Carolina. By that time he had begun to paint abstractly. He credits his foray into nonrepresentational painting to the experience of seeing a Nicolas de Staël abstraction at the Venice Biennale while in Italy on the Milliken Fellowship. De Kooning's work had suggested some of the possibilities of abstraction, but it was the de Staël that really swayed him. (The course of Brandt's art— figurative, abstract, then figurative again—also bears a resemblance to that of de Staël.)

The Brandts remained in Winston-Salem for a year, then returned to New York, where Carolyn worked as an editor for *Saturday Review* and Warren taught at Pratt and painted. Once again he rented a studio in the building on West Tenth Street. During those two years in New York—1951 and 1952—Brandt also took several art-history courses at the New York University Institute of Fine Arts, including a seminar on Goya that he especially enjoyed, in part because of the repeated trips to the Frick Collection that it necessitated. Then Carolyn became pregnant and, after making arrangements for Philip Guston to take over Warren's fine studio space, the Brandts went back to North Carolina. They bought an old house in the country near Greensboro, and Warren built a studio in which he painted daily. He also attended the University of North Carolina in Greensboro, where he received an M.F.A. in 1953.

After three years back in the South the Brandts borrowed two thousand dollars to build a second studio building in which Warren intended to teach art, but they used the money instead to go to Europe. To hear Brandt describe the trip, one is struck by his rare ability to remain untouched by the ambitions and stress that dominate the lives of most men at an equivalent point in their lives. Even as a broke young father, he knew how to savor living. He could subjugate strain as surely as he could eliminate ugliness from his art. In life as in painting, this achievement was the result of choice and effort, never of blindness or shallowness.

The Brandts, with their baby daughter Isabella, sailed on the Queen Mary and went first to Paris. They took up residence in Pontoise so that Warren could paint the same landscape as Pissarro, but their accommodations were miserable and the town confining, so after a month they decided to move to Spain. They bought a Citroën Deux Chevaux for one thousand dollars even though that left them with only a few hundred dollars. They drove to the Costa Brava, and almost the moment that they saw the beach, in a town called Blanes, they decided to stay. Today Blanes is a tourist mecca; in 1954 it was still very poor. They found a house with an annual rent of seventy-five dollars and hired a cook and a baby-sitter for next to nothing. Warren drove the Citroën back to France, sold it for what he had paid for it, and returned to Blanes. He rented a studio. "There were good models, and a marvelous atmosphere. In a nearby café Spanish men got together to sing in the late afternoons." Carolyn was as happy as Warren. The local wine cost a pittance, fish for paella was plentiful, and the villagers loved Isabella. "It was paradise." *After the Bullfight* (page 20), an ink and gouache drawing from that trip, captures something of the appealing daily life and of Brandt's firm emotional and painterly grasp of it.

The time they spent in Spain was ideal, but only because they knew how to ride with change, relish the moment, and avoid preoccupation with future plans. Brandt has a quiet

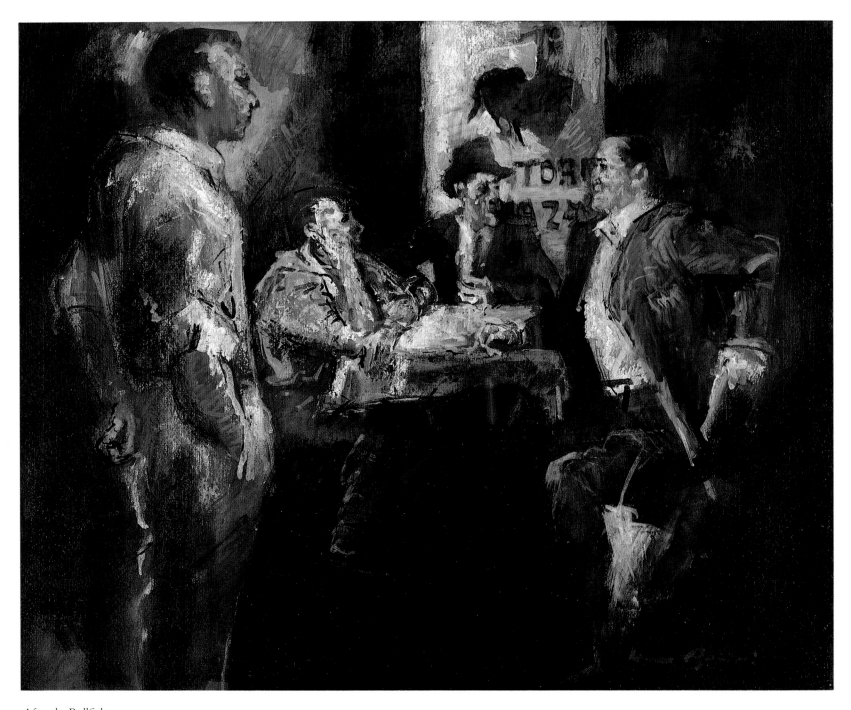

After the Bullfight
1954
ink and gouache
18½ x 23 inches
Collection: David Allen, Greensboro, N.C.

smile on his face when he explains, "Life has always fallen in my lap." The same smile appears when he tells about how, on his way to the bank in order to borrow the money for the house near Greensboro, he went into the men's clothing store he had frequented since boyhood to buy and put on a white cotton suit and Panama hat. The banker sensed prosperity and gave him the loan. It is not that Brandt is a hustler; he is just someone who knows how not to suffer. Prosperity, after all, is as much attitude as fact.

After nine months in Spain, the two thousand dollars were virtually used up, and the Brandts returned to Greensboro. The need to move was no hardship, according to Brandt, who explains, "I've had a good life, always." He managed to pay back the loan fairly quickly. He would often drive to New York for long weekends of looking at art and seeing friends. The Cedar Bar was then in its heyday, and a lot of the regulars were friends of Brandt. He had gotten to know them during his last stay in New York; his studio on Tenth Street was only a few blocks from the famous artist's hangout. He was close to both Franz Kline and Willem de Kooning, as well as to some of its lesser-known habitués—painters like Steve Pace, George Spaventa, Milton Resnick, Herman Cherry, and Paul Jenkins. Not only did he see them on his jaunts back to New York, but he sometimes hosted them down South. At one point John Opper, who was a professor at the University of North Carolina, arranged for an exhibition of some of the Abstract Expressionists at the school, and for a lecture by the abstract painter George McNeill. McNeill stopped in at the Cedar Bar on his way out of New York, and found himself accompanied on the rest of the trip by Kline, Guston, Jack Tworkov, and the dealer Charles Egan. Brandt gave a lunch for the group, and he still remembers taking McNeill to the bank to cash the two-hundred-dollar lecture check, which McNeill split with his traveling companions. When the Cedar Bar contingent left Greensboro, they all went on to Black Mountain College in North Carolina to visit de Kooning, who was a guest teacher there.

In 1957 the Brandts moved back to New York, where Warren taught and Carolyn became the editor of a small magazine. In 1958 he began a two-year stint at the University of Mississippi as chairman of the art department. Since Carolyn had health problems, the warm climate was desirable. During those two years, the Brandts spent their summers in Provincetown. They rented a cottage, and Warren found a burnt-out building on the sand dunes nearby that was used for practice by the local fire department. It still had ceiling beams, so Warren picked up two old rugs at a nearby dump and stretched them across the beams to form a roof. He tar-papered what remained of the sides of the building, leaving the whole northern exposure open except for chicken wire. This was his studio. When it rained the water would rise over his ankles, but he worked barefoot. "One of my great discoveries that summer was that rain water mixed beautifully with oil paint. Years later de Kooning came to the same conclusion, using tap water."

Colossus of 1958 (page 22) is typical of Brandt's work at the time. His is a relatively gentle sort of abstraction, one in which an eye for balance and composition prevails over personal expressionism. We approach this sort of painting visually, playing the reds against one another, reading the structure. The work does not appear to be a signpost of private emotions; nor does it inspire vast spiritual interpretation in the manner of the New York

Colossus
1958
oil on canvas
24 x 30 inches

school of Abstract Expressionism that was prevalent at the time. Brandt's abstractions are not lacking in spirit—they are animated, sometimes playfully, sometimes almost with a gentle fury—but one feels the abiding diligence behind them, the constant awareness of tempo and form. Brandt says that there were always figurative ideas behind his abstractions, that he started with a figure or other representational imagery which would later disappear completely. No such imagery is evident in *Colossus*, but there are the strong compositional sense and eye for rhythmic variation that exist throughout Brandt's work, from the purely abstract to the most voraciously representational.

In 1960 Brandt became chairman of the art department at Southern Illinois University in Carbondale, where his first marriage came to an end. A few months after the Brandts split up he met an art dealer and painter named Grace Borgenicht in New York. They were married that same year, and the marriage to this day seems as felicitous and well grounded as Brandt's most exuberant canvases.

They had their wedding in Manassas, Virginia, during Christmas vacation. Both recall the event laughingly. People went to Manassas because it was possible to be married in a hurry there. With Warren's sister and Grace's three daughters and his own in tow, they looked for a rabbi, minister, or judge to perform the ceremony. They finally found a Lutheran minister and celebrated at a hectic lunch dominated by all the little girls. Afterward, Warren had to return quickly to Carbondale, Grace to New York.

Brandt made Carbondale into much more of an art school than it had ever been before. When he arrived he thought "it was one of the poorest art schools" he had ever seen, so he did his best to instigate changes. He established drawing classes five nights a week and required art students to attend at least three of them. He arranged for visits from painters and sculptors like John Grillo, Sidney Geist, Reuben Kadish, Paul Burlin, David Slivka, Milton Resnick, and Edward Dugmore. He also personally raised $100,000 from Mr. and Mrs. John Russell Mitchell, art collectors who lived not far from Carbondale, in order to create a gallery space at the university and establish an exhibition program. As director of the Mitchell Gallery, he was able to show work by many of the New York Abstract Expressionists he admired.

Grace flew out for the opening of the Mitchell Gallery, which took place shortly after their wedding. The first show was of Mr. and Mrs. Mitchell's personal collection, consisting of work by George Bellows, Mary Cassatt, Arthur B. Davies, Maurice Prendergast, and others, and of paintings on loan by Alexander Brook, Thomas Eakins, Walt Kuhn, and John Twachtman. Warren was living in "a small, run-down house," but Grace borrowed furniture to make it presentable for the party after the opening. "In the morning before the

opening, she made a wretched front yar' into something beautiful. She broke off branches from trees behind the house and plan* .d them as if they were seedlings; she planted flowers from the local nursery and made an instant garden. She's a doer, that Grace." Today the Brandts live in larger, more comfortable and elegant spaces, surrounded not only by Warren's work but also by much-cherished masterpieces of Bonnard, Matisse, Degas, and others; the details have changed considerably, but the atmosphere and intensity of pleasure are the same as in the Carbondale days.

Brandt's work from Carbondale shows the increasing vigor, both in color and in form, of his foray into abstractionism. From quick drawings or temperas of figures—generally of moving bodies, often of people making love ("It gave me a starting point, better than just a dash of color")—he developed large canvases of prodigious energy. *Illinois Landscape* of 1959 (page 25) has the play of animation against void, the system of thrusts and counterthrusts of a painting like *Tulips, Lilacs, and Dogwood;* with its raw brushstrokes and uncompromising colors, it has a rare vitality. Later on Brandt's technique will function in the service of an overall pictorial scheme; here it is part of an adventure of unbridled enthusiasm and near recklessness. It is no surprise that Brandt was deeply moved by the abstraction by Nicolas de Staël that he had seen in Venice in the late 1940s; de Staël's sort of passionate intensity, his non-stop eye, and his continuous sense of motion are not far from Brandt's concerns. The paintings that particularly are brought to mind by *Illinois Landscape* are de Staël's "Footballeurs" series of 1952. In those paintings, based in part on his viewing of a soccer match, the crashing contact of well-coordinated bodies and the sense of total mental and physical engagement are rendered with marvelous intensity. Brandt, like de Staël, uses pure energy-laden colors, plays form against form, and never wavers from a grasp of the overall integrity of the canvas. Like artists from Uccello to Velázquez, these moderns understand the enchantment of a complex pictorial system, no matter how abstract the context.

Brandt's second marriage marks the beginning of the current period in his life. After another year in Carbondale, he moved to New York, which, with eastern Long Island, has been his home base ever since. There have been months in the south of France and a couple of winters in Mexico, but for the most part the Brandts have spent four days of the week in Manhattan and long weekends and vacations in Water Mill, near East Hampton. Warren has always maintained a studio, separate from their residences, in both locations. There have been regular exhibitions—one-man shows in galleries as well as group shows—and frequent write-ups in newspapers and the art press. And although Warren continued to paint abstractly for a few more years, in the early 1960s his work lost its previous stridency and began to acquire the warm, rather lyrical quality it has had ever since. By 1964 he had begun

Illinois Landscape
1959
oil on canvas
66 x 102 inches
Collection: Grace Brandt, New York, N.Y.

consistently to focus on the representation of the world around him, a goal that has become increasingly obsessive over the years. If his abstract painting always had subject matter as its underpinning, now the subject was what the paintings were essentially about, although a resemblance to the abstract work was at first very strong.

The transition from abstraction back to representation indicated more of a change of concept than of the appearance or overall spirit of Brandt's work. *Candlewood* of 1961 (page 26) has no subject matter in the literal sense, but it does convey a definite sense of three-dimensional space. Painted in a studio Brandt had on the Bowery, it suggests the drama of a cave interior, of a place of depth and mystery. It reveals great certainty, about form and about where to place which color and how to wield the brush. The ever-conscientious artist, true to strong convictions about his craft and with a sure eye for balance, is in charge. As in *The Descent* and *Interior with Figure* of 1963 (pages 27 and 28), he achieves enormous pictorial drama. Rhythm and careful color orchestration prevail. A continuous spatial

Candlewood
1961
oil on canvas
50 x 60 inches

The Descent
1963
oil on canvas
72 x 80 inches
Collection: Isabella Brandt, New York, N.Y.

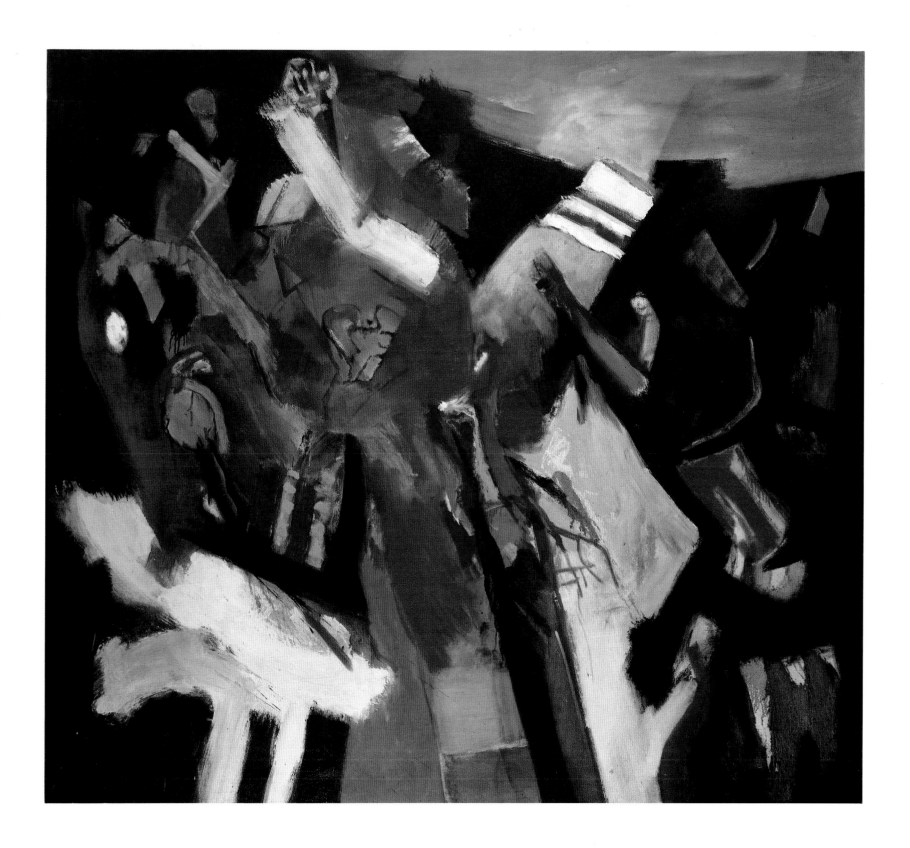

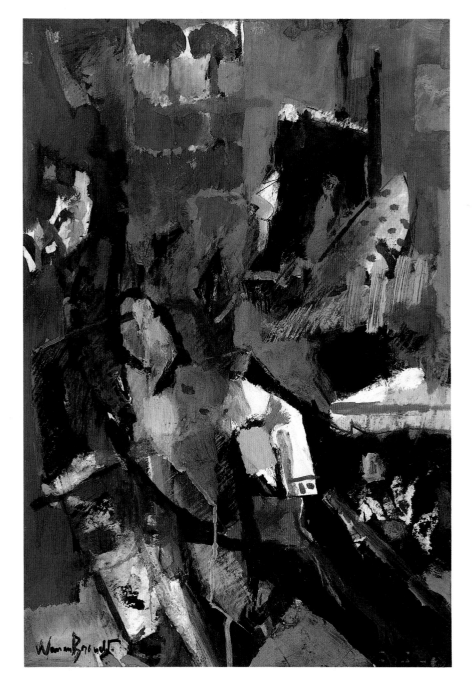

Interior with Figure
1963
gouache and collage
23 x 17½ inches
Collection: Nicholas Fox Weber,
Bethany, Conn.

movement occurs. And in these last two works we are really on our way into the known world. *The Descent*, as its title indicates, has both the tragic mood and the physicality of sixteenth- and seventeenth-century paintings of the Descent from the Cross. *Interior with Figure* hints at a person in a room, at books and other objects, at a Vuillard-like sense of complication and of the relationship between the spaces in which we live and the interiority of our minds. There is clearly a window—with its wonderful suggestion of light, air, and openness—that frames two trees. We see both complexity and its antidote here, representationally as well as abstractly.

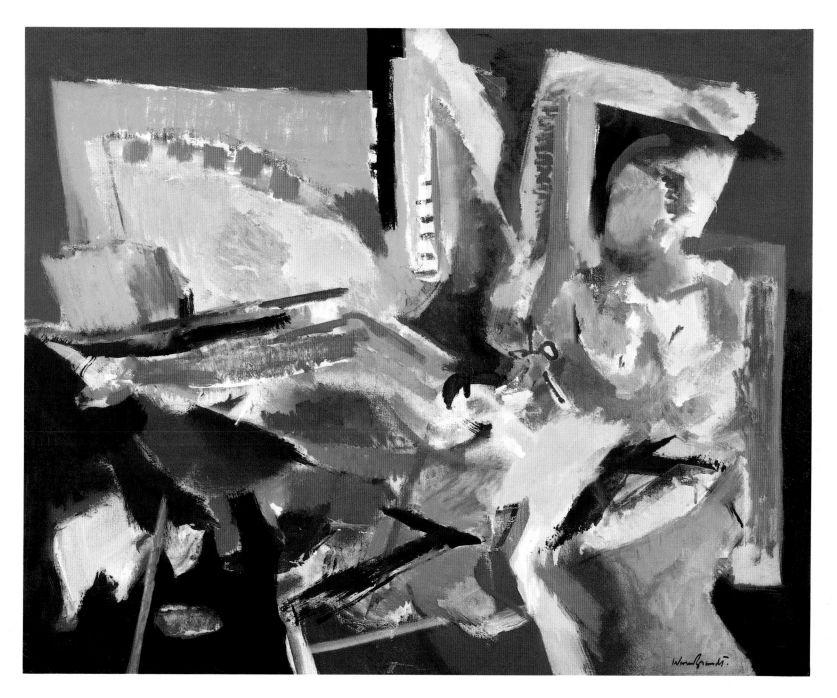

In the summer of 1962 Brandt rented Franz Kline's studio in Provincetown. Kline's brushes and palette were still in place. "I am sure that the heavy large black strokes that came into my work of that period were somehow related to Kline's presence, which permeated the studio." Even if Brandt's work at this point suggested more of earthly reality than did Kline's canvases, there is a shared intensity, a similar physicality and robustness in the work of both.

The Bride of 1963 (page 29) is an important transitional painting to the sun-drenched interiors that Brandt began in full force in 1964. As inventive and nonliteral as many of

The Bride
1963
oil on canvas
47 x 58 inches

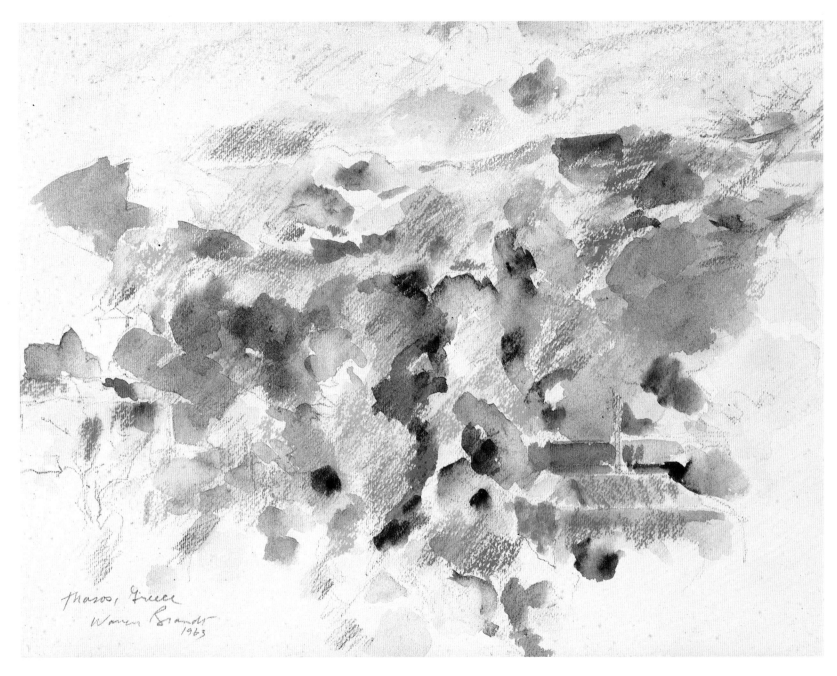

Thasos, Greece
1963
watercolor
9 x 12 inches
Collection: Dr. and Mrs. Arnold D. Kerr,
Wilmington, Del.

its forms are, it is definitely a figure painting. It is also lighter of hue, more playful and welcoming in tone, than some of the preceding works. We are on our way toward a quality of lyricism—to some of the strong softness that is evident in the watercolors of *Thasos* (pages 30 and 31) that Warren did when he and Grace were traveling in Greece.

In 1963 the Brandts moved into their first house in Water Mill. It was a large old house in disrepair, and Warren transformed the second floor of the former servants' quarters into a two-story-high studio. At the same time, de Kooning was building a studio out in Springs, on the other side of East Hampton. "He approached building like painting, and would put things in and then take them out, constantly revising the space. So when he had four

Thasos
1964
watercolor
6 x 9 inches
Collection: Grace Brandt, New York, N.Y.

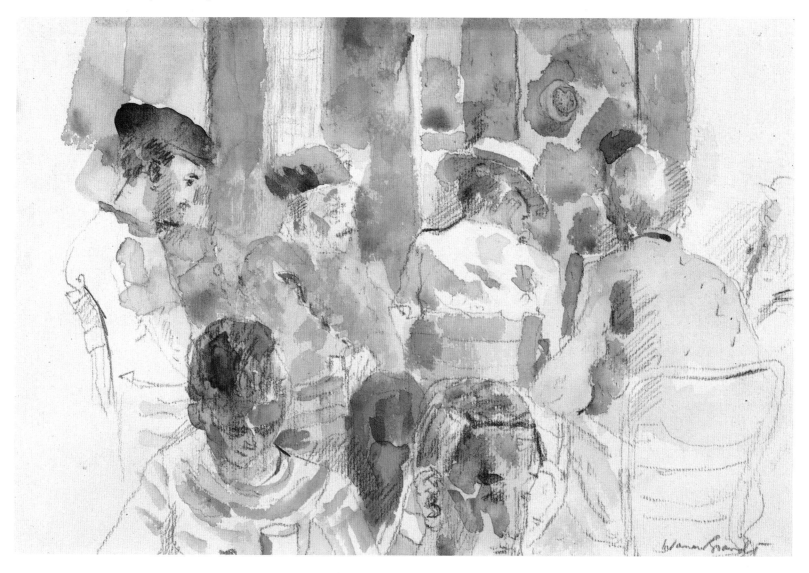

enormous windows left over, I bought them for practically nothing." They became a
two-story glass wall on the north side of Brandt's new space.

Some of his large canvases from 1964–66—*Living Room (with Red Table and Two
Figures)*, *The Bath—Water Mill*, *Berta's Bath*, *After the Shower*, and *The Morning Paper* (pages
32–37)—add a whole new breadth to Brandt's achievement and reflect his new way of life.
We are now in fully developed domestic interiors in which some of the lessons of de Kooning
(and of Abstract Expressionism in general) have been applied to a world that belongs more
to the realm of the French Intimists. The atmosphere of these pictures is almost vaporous.
The boundaries of people and objects are somewhat hazy. We feel as if we have come upon

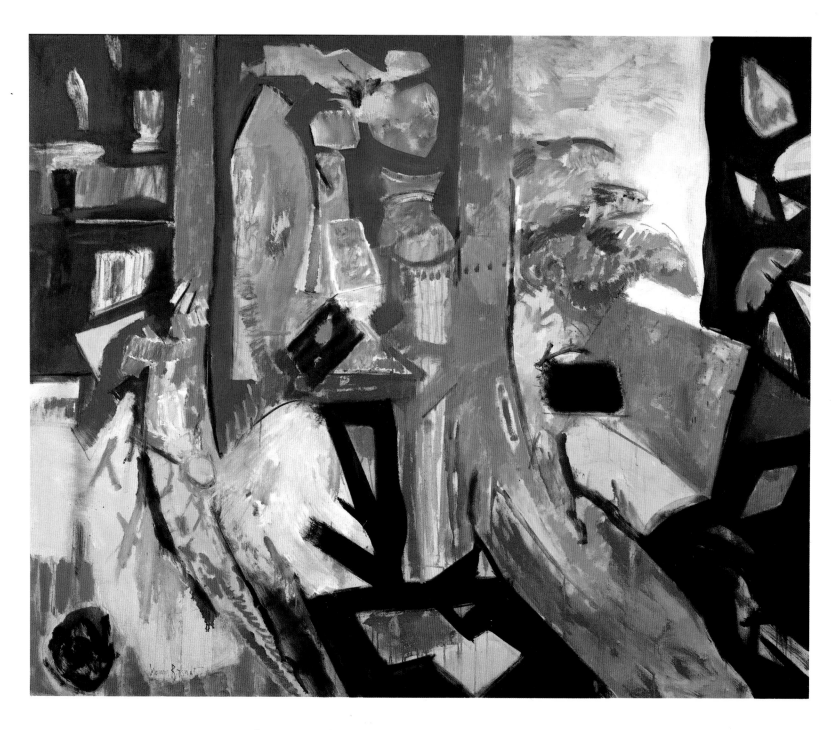

Living Room
(with Red Table and Two Figures)
1964
oil on canvas
66 x 80 inches

these scenes from another planet. In fact, the artist had come upon them after a long period of immersion in rather different concerns, and the tentative nature of his focus in his new arena seems quite deliberate. The thin wash of oil paints, the frank brushiness, and the animated surfaces of these large interiors enhance their feeling of intimacy. The work is impressively sketchy, free, relaxed.

We feel that no judgments are made; whatever is to be seen in the chosen corner of a room—the exposed radiator, the very "sixties" sofa, the pots and pans on the wall—will be

included. A constant warm light bathes everything equally. In subsequent work we will feel Brandt selecting and arranging his elements more actively. But here, more than anything it is a general concept of reality that concerns him. He had been thinking abstractly; now he has opened his eyes to ordinary daily sights and taken them rather nonselectively. In time the focus will become more precise, the colors more pulsing, the volumes more strident. Now there is softness—the muted voice that comes from knowledge rather than weakness.

Living Room (with Red Table and Two Figures) is an early example of a subject that Brandt approached often in the 1960s: his daughter Isabella and Grace's daughter Lois immersed in a pleasantly languorous summertime existence. Berta (of *Berta's Bath*) is another of Grace's daughters; domestic life with adolescent girls gave Brandt rich subject matter. He has not just captured the appearances of the household; we feel some of the frenetic, multidirectional quality of adolescent life in these paintings. Random thoughts are suggested by brushstrokes that have no specific visual reference; intensity and passion are implicit in the colors. The works are full of light-footed motion. The freedom and animation of Brandt's abstract style perfectly suits the now recognizable subject matter. In these highly charged and rhythmically lively compositions, the figures are only partially legible, but the way in which only a degree of reality can be grasped conveys a vital element of the human experience.

Warren Brandt, 1964

33

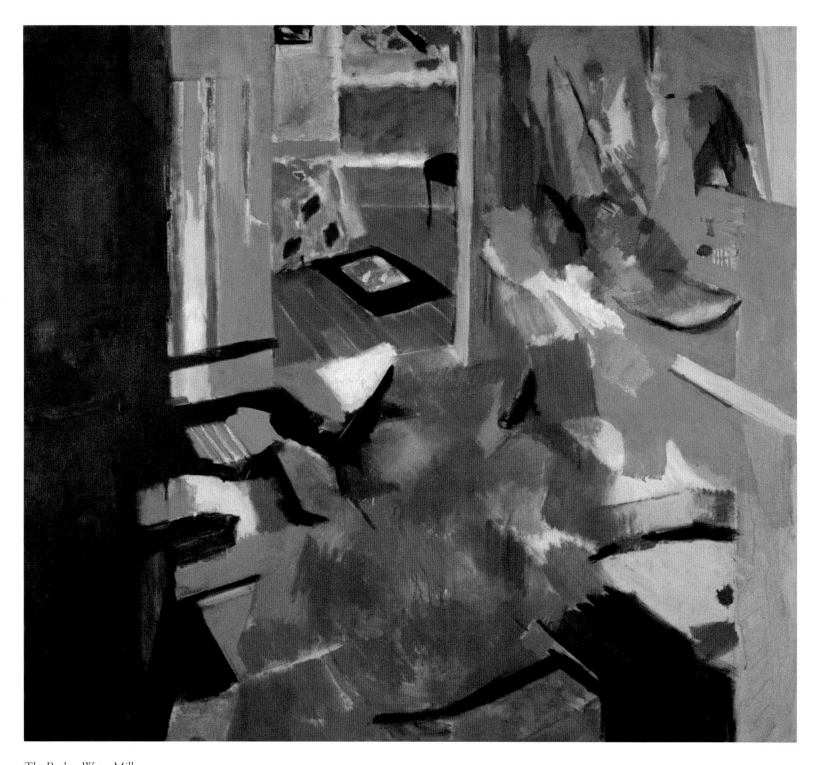

The Bath—Water Mill
1964
oil on canvas
72 x 80 inches
Collection: Memorial Art Gallery, University of Rochester,
Rochester, N.Y. Gift of Mrs. Albert List, 1964

Berta's Bath
1964
oil on canvas
78 x 66 inches

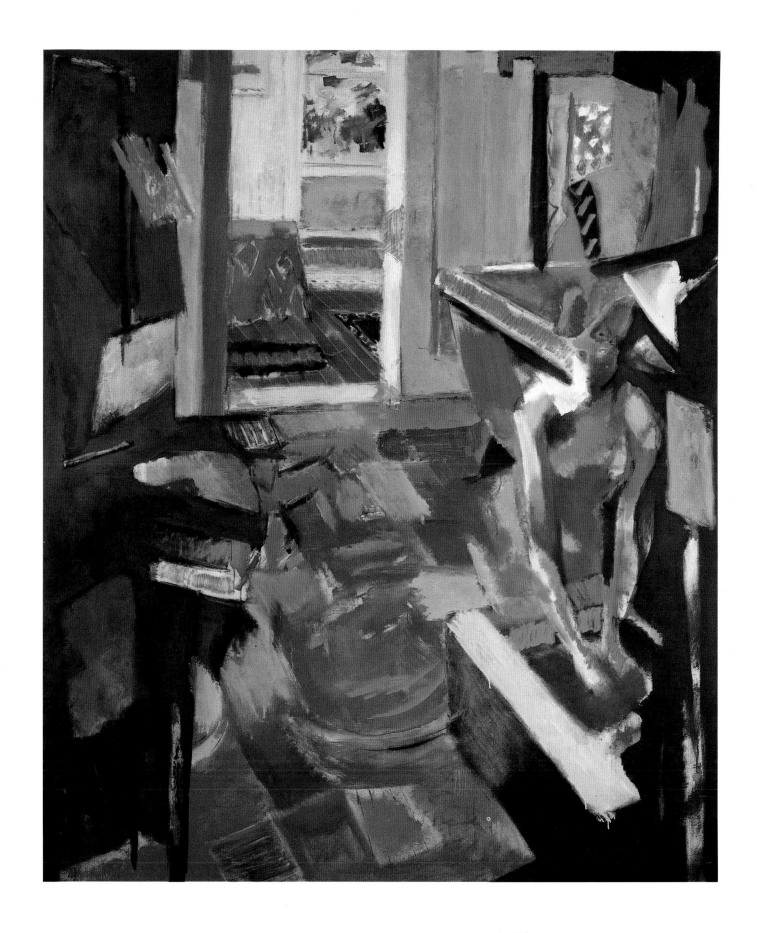

After the Shower
1965
oil on canvas
70 x 50 inches
Collection: Dr. Coker, Arlington, Va.

The Morning Paper
1966
oil on canvas
60 x 70 inches
Collection: Hirshhorn Museum and
Sculpture Garden, Washington, D.C.

In *Blue Nude* of 1965 (page 38) the figure has more of a sculptural, plastic presence than has existed in Brandt's work to date. We feel his quest for a new sense of solidity, for the serenity of tangible masses and broad, flat surfaces. His deliberate sense of frenzy is gone. Now we have a careful penetration of three-dimensional space by a complex system of precisely articulated curves. The tone is more gentle, more mellow. The subject matter is less specific—the general idea of the female nude, in a studio setting, rather than specific family members surrounded by the personal objects of the artist's household. Soothing expanses of dark and light blue play gently against one another; the model's arm is melded to the top of the curved armchair. The overall effect of the setting—with details like the red stripes on the blue drapery material—is of harmony and grace. With her relaxed pose and statuesque presence, the nude woman is a portent, and an early successful realization, of the aspirations and achievements of Brandt's figurative work. *Moroccan Chair* of 1966 (page 40) is another variation of many of the same ideas.

In *Summer* of 1966 (page 41) there is a fascinating merging of background and figure, so that the person shown appears to move in and out of space at the same time. She has the convincing solidity of the figure in *Blue Nude*, even if the setting is lighter and more painterly. This same combination—of an impressive freedom of the brush with a convincing realization of massive, three-dimensional figures in a legible space—is apparent in *Sisters* (page 42) of the same year. It was a time when Brandt was producing some of his most appealing domestic scenes, canvases that to some degree do for American life of the period what Vuillard did for aspects of bourgeois living in turn-of-the-century France. *Berta and Grace*, 1966–67, and *Checker Game* of 1967 (pages 43 and 45) are particularly evocative and pleasing. *Isabella and Lois* of 1968 (page 47) is another canvas of the period that succeeds as a depiction of two women in an interior, although there is increased emphasis on pattern and surface animation. Grids play against stripes; curves counterbalance one another. Forms have been flattened, space compressed. There is lightness in both weight and tone—in the luminosity and in the way that the paint has been applied almost nonchalantly. The two women facing one another are composed of little more than a few thinly stroked blocks of color. Yet enough is shown so that we can apprehend the relaxation of their poses.

We sense the ease of the relationship between these two women. Since we can make out nothing of their faces, our ability to feel this attitude so certainly is clearly the by-product of color and form and other purely painterly elements. Brandt establishes a mood not by describing it, not by illustrating it in the usual way, but through visual persuasion. The blues and yellows make an ambiance of irrefutable gentleness. The grid of the French door is soft, lyrical, almost playful. As a result, we feel that Isabella and Lois exist in great harmony in this room together. The figure on the right sits in a pose that implies pure relaxation, plenty of time to concentrate quietly on a game or conversation. She occupies the circular rug perfectly. There is kindness here, and no sense of hurry; this feels like a vacation summer afternoon in the life of adolescents. The checkerboard (with its echoes of

Blue Nude
1965
oil on canvas
50 x 40 inches
Collection: Isabella Brandt, New York, N.Y.

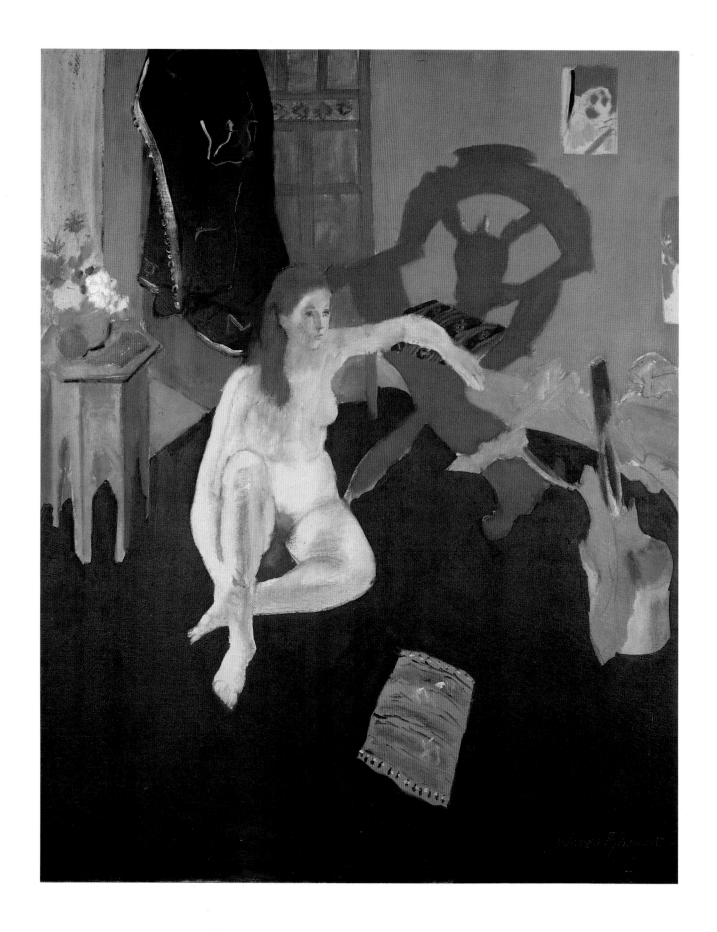

Moroccan Chair
1966
oil on canvas
50 x 40 inches
Collection: Beaumont Art Museum,
Beaumont, Tex.

Summer
1966
oil on canvas
48 x 36 inches

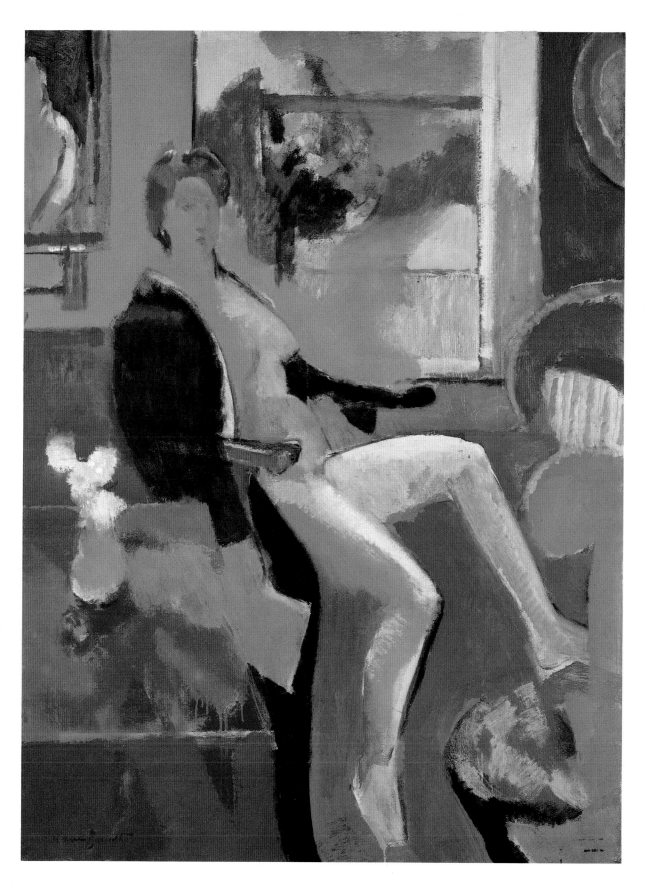

Warren Brandt, 1965/66

Sisters
1966
oil on canvas
36 x 34 inches

Matisse) symbolizes playfulness, the role of quiet diversions. In other paintings of the period we see people reading newspapers or nudes stretched out in armchairs—as if there is nothing in the world to do for the time being but luxuriate. Especially when considered in light of other American art of the time, these canvases of Brandt offer rare respite.

In the March 1966 *Art International* critic Kenneth Sawyer assessed Brandt's position and achievement at that point:

> No one in the United States today, I think, has Brandt's command of color. In a decade of monochromatics he has remained uninhibited in the use of pure primaries. This in itself, obviously, is no particular virtue. But when undertaken

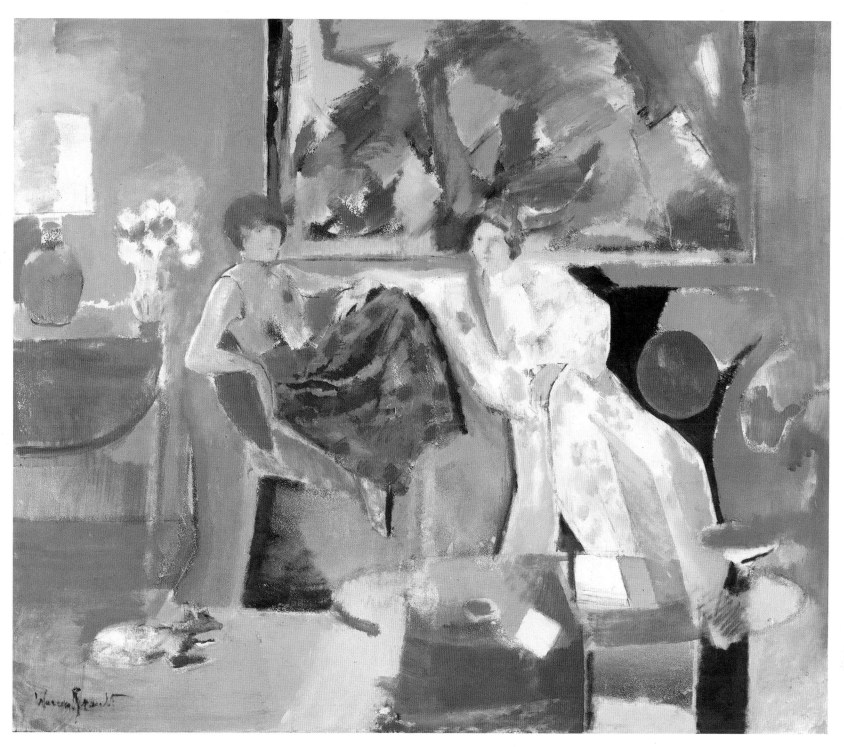

Berta and Grace
1966–67
oil on canvas
78½ x 92⅞ inches
Collection: Archer M. Huntington Art
Gallery, University of Texas at Austin, Tex.
Gift of James and Mari Michener, 1968

Turkey and Cocks
1967
pencil
5½ x 7 inches

Checker Game
1967
oil on canvas
60 x 50 inches
Collection: Guild Hall, East Hampton, N.Y.

by an artist whose birthright is color, the free, relaxed juxtapositions of the most vibrant cadmiums is sheer seduction of the eye wearied by dun tonalities. His oils are never less than sensuous; and they are always more. . . .

Content for Brandt may mean anything: a window, a table, a barn, an inexpressibly lovely nude. It is his means that are all important. Perhaps the secret is his fundamentally tender feeling for each object he undertakes as subject. This is by no means to say that Brandt treats his matter sentimentally. For many years he was a non-figurative painter, manipulating colors and forms at once boldly and sturdily. No softness; but a glorying in the possibilities of hand and eye and knowledge working in close harmony. The results were paintings of unusual richness and power. . . .

A few years ago Brandt returned to figurative art. It was, at that moment, an unfashionable move, but one that was inevitable in his development. . . . His painting changed, but so subtly that only his firmest admirers were aware of it at first. The palette remained, warm and variegated; it was the forms that grew firmer, that were clarified. Brandt had returned to an art that had remained close to his deepest feelings—that of France at the turn of the century. He calls himself an European painter. This is, I think, a just estimate, but one which must not be misinterpreted. . . .

We have become polite. And that is the death of art. Brandt dares to be gorgeous in an almost oriental way. He dares to exult. His celebration of a commonplace domestic scene adds an unexpected dimension to domesticity; pleasantry mingled with poignance—all managed with the flick of a brush. The simplest scene (none of his scenes is really simple) assumes a celebrative quality. . . .

Brandt's technique seems casual beyond measure, but it remains strangely and movingly effective; as if he were the keeper of a secret guarded from the rest of us. He may well be.

The secret, and the technique, were enchanting many. Brandt had his first one-man show—at the Nonagon Gallery in New York—in 1959; in the early 1960s he had solo shows in Provincetown and Washington, D.C., followed by more one-man shows in New York, at Grippi & Waddell in 1964 and A. M. Sachs in 1966 and 1967. In 1968 there was a major piece about him by fellow painter Herman Cherry in *Artnews*. If Brandt was not at the forefront of the art scene—the sort of trend-making style that was finding its way into society columns and spreads in news magazines—he had truly arrived among fellow painters, art critics, and devoted collectors. And his place was a rather singular one. While similar on some levels to painters such as Fairfield Porter, Nell Blaine, Jane Wilson, and Jane Freilicher, Brandt was working in his own distinct way, somehow more French, more effusive than the others. Brandt has his abiding loves and a devil-may-care attitude toward current movements and prevalent ideas of "good taste." He was moving surely and confidently toward the ebullience that has come to mark the work of the 1970s and 1980s.

And still she slept an azure-lidded sleep,
In blanched linen, smooth, and lavendered,
While he from forth the closet brought a heap
Of candied apple, quince, and plum, and gourd;
With jellies soother than the creamy curd,
And lucent syrops, tinct with cinnamon;
Manna and dates, in argosy transferred
From Fez; and spiced dainties, every one,
From silken Samarcand to cedared Lebanon.

from JOHN KEATS, The Eve of St. Agnes

Brandt's work of the past two decades can be divided roughly into several categories. There are figures in interiors, self-portraits, still lifes, and landscapes. The elements almost always commingle: a window opening on the local landscape in a self-portrait, a still life of flowers in the background of a nude in an interior. There is a constancy to Brandt's passions, to his chosen subjects. Similarly his general goals—simultaneous pictorial harmony and liveliness—pervade.

The large *Studio Interior with Model* of 1977–78 (pages 50–51) that hangs in the Brandts' New York apartment is in many ways the apotheosis of the nudes. Here is Brandt as we know him today: a painter trying to tell all and give everything he's got. He wants those volumes —the shape of objects, their weight, the way they displace air in a room. He wants rhythm on the surface of the canvas as well as complex three-dimensional movement within a knowable space. He wants color that will grab us without compromise. Life and art are unbridled.

As with his *Artist in His Studio* (page 10) he has shirked nothing here. He has given himself the toughest possible tasks: a kimono and towels draped on an armchair, a silky shawl over a screen, and again his own reflection in a mirror. He wants to capture the difference between flesh reflected in glass and naked flesh directly before our eyes. And he wants to make myriad angles and curves all work.

He does all this with unabashed golds and crimsons, yellows and pinks. The statement he could make in *Isabella and Lois* (page 47) he can now make louder and clearer. But he is by no means out of control; he can be all the more absolute because his control is now steadier and surer. He knows just the quantity and the light intensity of the blues necessary to keep the more fiery colors in their bounds.

In works like this Brandt reveals himself as a Romantic in the tradition of Keats and Byron. Candidly, effusively, he voices his passions: for flesh, for the opulence of the East, for a complexity of sensations. Many of his canvases have the intense fabric—the rich mosaic with its internal rhythms—of the most sumptuous nineteenth-century poetry.

There is a wonderful confluence of objects in *Studio Interior with Model*. The Japanese print, Brandt's palette, and a particularly well-articulated bouquet of mums all interact easily against an attractive dusty blue wallpaper. The palette is one of the many distinct reminders here of the art of painting. We are looking not just at the world, but at the inside of a studio—the workshop of someone who will deliberately use every possible means to reproduce that world. We see the paints themselves (on the palette), and we see an easel with a painting on it. The painting on the easel echoes *Studio Interior with Model* itself, suggesting that although we are glimpsing life in this painting, we are also looking at a flat object that must lean or hang. Thus has Brandt called attention to his craft.

The choices of his references to other masters of his craft are telling. The painting on the easel, while in fact one of Brandt's own watercolors, is clearly a reference to Cézanne's

Isabella and Lois
1968
oil on canvas
50 x 60 inches
Collection: Mrs. Rita Polkes, New York, N.Y.

Warren Brandt, 1971

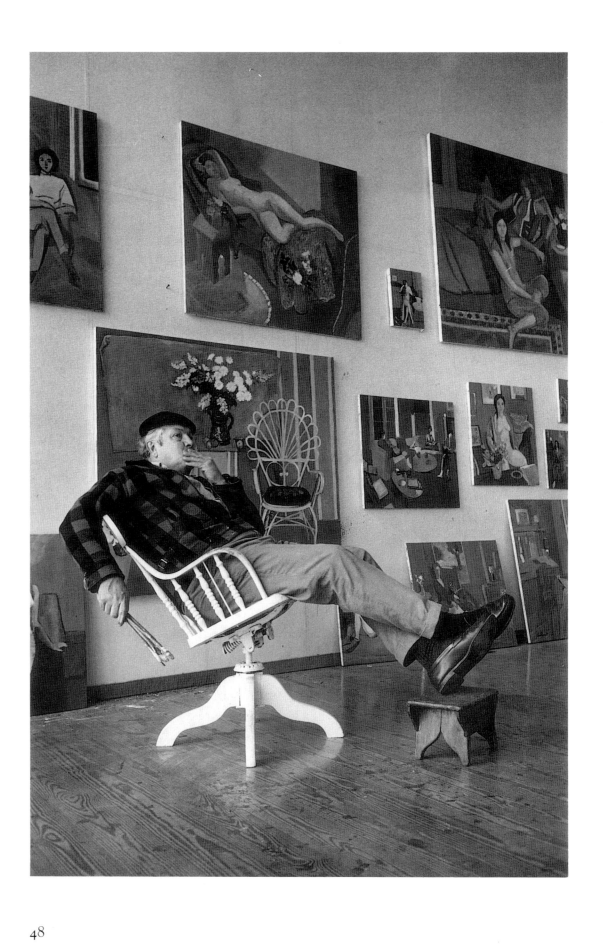

Mont St. Victoires. Brandt has no problem in letting us know who his heroes are and where he has come from. He has accomplished a certain feat in his method of making this statement by choosing to reproduce a watercolor here with oil paints; he establishes the light washes of one medium perfectly with another.

Cézanne is one hero; Matisse is another. And Manet is a third, it seems, so precisely is the nude model's pose, especially with the fallen slipper, a reference to some of Manet's Spanish figures. On the easel, along with the Cézanne-like watercolor, is a copy of *The Art Gallery* magazine with a Matisse still life on its cover. And on the seat of the armchair covered in red in the left foreground is a catalogue of paintings from the Soviet Union with a Matisse on its cover. This is not just any Matisse, either; rather, it is a detail of a Matisse studio interior. We are looking at a reproduction not of Matisse's famous *The Dance* but of the 1912 studio interior (*Nasturtiums and "The Dance"*) in which the large canvas of *The Dance* is shown leaning against a wall. So we see artists conscious of their craft, their goal, their attempt to transform reality through the means of paint and canvas. Their own art work is one of their greatest subjects. Both painters, Matisse and Brandt, have called attention to the means by which they present vitality and movement; the flow in Matisse is as much the motion of painting as of dancing. Another way in which Brandt seems to remind us of what he does as a painter is the way he has painted the two projections at the bottom of the Moroccan mirror in which he is reflected. His primary goal has been to capture that mirror authentically—indeed, we know its shape, color, and patina—but having presented the facts, he has deliberately gone further. He could easily enough have painted those bottom projections as the symmetrical images that they are. But instead he has taken them on a flight of fantasy. He has distorted them with an eye to motion, to spiritual freedom, to qualities that supplement the depiction of actuality. He has treated those shapes in much the same way that Arp manipulated forms—playfully, lyrically, with a sense of the way that abstract elements can create a mood of tranquillity.

Of course, the focal point of the painting is the naked woman. She loves her own allure. To be beautiful and sensuous, to have the power to attract, gives her vast pleasure. The wonder of appearances—the idea, however ancient, of loveliness—fuels Warren Brandt's work, and this woman's straightforward joy in her traditional femininity sums up much of the spirit of his art.

It is the tone of her flesh, the way her body really exists as something warm and living, that makes her so different from everything else on the canvas. The rest of the painting seems in many ways to be mainly an embellishment to this frankly suggestive Venus. Humanness—and, implicitly, lust, the enjoyment of one's own being, the anticipation of pleasure—dominates. One thinks of the role of what people are doing in the paintings of Rogier van der Weyden, as discussed by Erwin Panofsky in his seminal *Early Netherlandish Painting*. Panofsky charted the progress in van der Weyden's work beyond the achievement of his predecessor Jan van Eyck. Van Eyck showed all the details of an interior—church sculpture, liturgical objects, the view out the window, the human beings present—in such a way that they assume equal levels of importance. In van der Weyden the figures come to the fore both physically and spiritually, with everything else receding so as to be incidental to

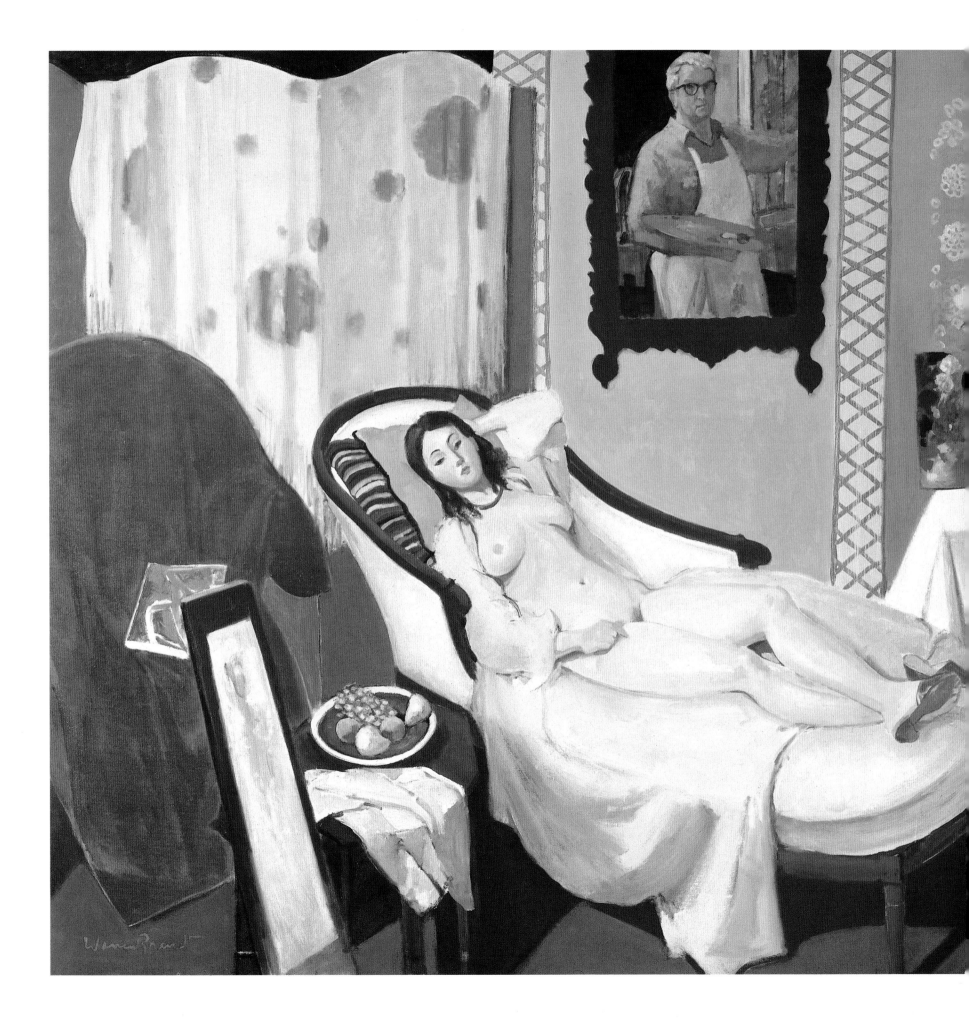

human action. Brandt's figures, like van der Weyden's, are never merely part of an interior; they are the focal point.

Brandt himself—present in the mirror much as those Flemish artists were often reflected in looking glasses or other shiny surfaces in their paintings—is just one step beneath the woman in the hierarchy of the picture. He seems to be looking at her but also at his easel. We feel that he regards his model both as an artist approaching his subject and as a man whose eyes are riveted on the body of a beautiful naked woman. Part of him is engaged in the task of painting, in the ongoing dialogue between what he is trying to capture and the method of trying to capture it. But this process has in no way made him stop living. In a century when many artists have very deliberately made the separation between living and painting, the simultaneity of human feelings and painterly feelings is pivotal to Brandt's work. Witnessing him here with one eye on life and one on his art, we see the combination that his work is always about.

The big forms hold their places in this painting. We know just how the figures are situated in the overall space, and how the chairs and other objects are positioned. The result is that there is a nice system of unifying rhythms; the furniture has been arranged with an eye for overall motion and harmony. At the same time there are some fine little touches, like the red slipper off the model's foot on the chaise longue. (That slipper not only recalls Manet, but is yet another reminder of Northern European art, where it is so often a symbol of domestic bliss.) The bowl of fruit on the table in front is an enchanting still life capable of standing on its own. The white bowl on the white tablecloth offers a delightful play of hues. Unhesitantly rich, generous in scale, *Studio Interior with Model* is a tour de force.

What has any poet to trust more than the feel of the thing? Theory concerns him only until he picks up his pen, and it begins to concern him again as soon as he lays it down. But when the pen is in his hand he has to write by itch and twitch, though certainly his itch and twitch are intimately conditioned by all his past itching and twitching, and by all his past theorizing about them.

—JOHN CIARDI

When Brandt paints in his New York studio, he looks very much as he does in *Studio Interior with Model*, one eye on his subject matter, the other on the canvas. He moves his head rapidly back and forth between the two, like a spectator at a tennis match during a long rally.

He is generally at work on four or five major paintings at a given time. For the past couple of years, there have been two canvases whose satisfactory resolution has continually eluded him. One of them is a painting of two women in a very Eastern setting. "It just keeps getting a little more done" as he intensifies a yellow "to get that leg in the light a little better" or "pushes those mauves down a bit" to relate the tones better. The other is a portrait of one of his collectors, a woman he considers quite beautiful but whose features have a quality he cannot capture to his own satisfaction. Just when he thinks he has it all, he loses it.

But endless changes and the unpredictability of the results, no matter how certain the initial concept, are what the process of painting is all about to Brandt. The need for flexibility, to be responsive to the altering rhythms and tonality of a painting, is always on his

mind, both in his own efforts and in the work of his heroes. "Degas was constantly making changes. Painting is a series of revisions and adjustments. That changing is what gives art its life—changing it, to make it work. None of Matisse's paintings are the way they started out, but they end up resolved. You have to search out your own solution. You have to put something down before you can change it, and then there is all the working out. Art is like one big puzzle, a growing idea that moves as you paint. And you have to be patient at the same time that you want to forge ahead. It's necessary to let a painting sit in between stages, to dry in the intervals. Colors have to set so that you can go over them."

As Brandt works away at a still life, we sense a bit of what the puzzle solving is for him. First he carefully arranges the objects themselves, with an eye to both color and the play of one shape against another. Then he composes the canvas, attempting to achieve accuracy in his reflection of the subject and at the same time obtain the balances and cadences unique to the painted picture. That is where the changes, the constant adjusting, enter in. "Matisse struggled with every painting, of course. The painting demanded it. He had to make changes, always. I'm not sure if that was as true for Picasso. . . . I feel that Picasso knew what he was doing—he knew how it would end up. And of course it always comes off. He had the genius to realize his concept just like that. Matisse, meanwhile, had to work very hard to do it, but he did. The struggle in Matisse is a big part of the excitement for me. Sometimes I just think that great artists fall into those two types. Hals was like Picasso. He didn't have to work so hard; he had the ability to make it come off, right away." Brandt concludes such remarks with one of his typical disclaimers: "I don't know if that's true, but I feel it."

The point toward which Brandt is working—the criteria that prompt the changes—is based on standards that are hard to pinpoint. His concept of perfection seems to derive from a feeling for the qualities that make paintings by artists as seemingly diverse as de Hooch, Velázquez, and Degas masterful for him: an ability to capture in some way the appearance of things, a feeling for large rhythms and the successful organization of the canvas. His goal has nothing whatsoever to do with the traits of art works as generally cited by critics and art historians, with "art as statement." The issue of interpretation—the discussion of theoretical themes that a painting might inspire—has no more meaning to him than a dissertation on the sociology of automobiles would have to a car mechanic. What he wants is for his paintings to work, even if he cannot be certain in advance exactly how or when it will occur.

While Brandt does not have his ultimate conclusion fixed absolutely in his mind, he knows when he has taken a right or wrong step along the way. And he is always contemplating his next move. That is why he "can't stand not to get to the studio early each day and work hard." And that is why he often wakes up in the night thinking about a painting— how to change a color or open up space. Sometimes when he is in the middle of some activity totally unrelated to his art, he will think of a solution for a picture. "Of course, when I get to the studio, more often than not I find that some other solution is better. But you have to try to solve problems in your own way; your ideas keep changing, but you have to try them as they occur to you. Some paintings take an awfully long time to develop; others come into place more quickly, but you never know just why it all goes a certain way. The thing about being a artist is that you just have to do what you do. It isn't easy to paint; you

have to plug away at an idea. Think of Matisse making an exact copy of de Heem—how he could stick to that. You have to be constant to your goals; if you mess around with too many ideas, you get lost."

He sounds at times like Renoir, whom he greatly admired. Jean Renoir wrote of his father, "The idea that intellect is superior to the senses was not an article of faith with him. If he had been asked to list the different parts of the human body according to their value, he would certainly have begun with the hands." He quotes his father, "'What is to be done about these literary people, who will never understand that painting is a craft and that the material side of it comes first? The idea comes afterwards, when the picture is finished. . . . We have to have a devilish amount of vanity to believe that what comes out of our brain is more valuable than what we see around us. . . . A painter's work is first and foremost with his hands and eyes.'"*

Brandt's struggle to get things right certainly never shows itself in the end product. The battle to make a painting work is between the artist and himself, that's all. The tremendous success of his art depends substantially on his own conscientiousness. Technically and aesthetically, he is an exacting coach as well as a determined player. Mindful of every detail, he is especially watchful for that vital moment when it is time to stop a painting. Sometimes it comes after long development, sometimes quickly. "When it feels just right—and you can't do anything more to it—that's when it's done. If you go on, you usually mess it up."

When discussing the optimal qualities of art, Brandt will again take up the subject of some of the superstars who in the early and mid-1980s have been dominating the New York art scene from Soho and the East Village right into the main galleries of the Whitney Museum. "You know, Renoir is beautiful; he's so natural. He was influenced by Cézanne late in his life, which is surprising because he was older than Cézanne. Matisse was influenced by Cézanne too. But it's not like the way everyone downtown is influenced—by an idea or a trend more than by a real concept of painting. It's a long cry from the way Renoir and Matisse would recognize what Cézanne did, but go their own ways." He derides current bandwagons, the shifting "fashions" of the current art scene. Among his contemporaries, the painter about whom he speaks most admiringly is Leland Bell, present in his personal pantheon along with de Kooning and Kline.

"I'm in favor of good painting, period. But there's so much painting that is not, to me, based on talent, or knowledge, or feeling. It's based on the drive to be successful. A good painting should be alive. It should move. When Matisse was talking about the armchair, he was talking about the way that someone could sit there and lose him or herself in the flux—the way that a thing moves and moves and moves." He misses this sort of living movement in some current popular painting; amateurism and pretense are anathema to Warren Brandt. To be less than truly devoted to the issues of painting as they have been approached by great artists throughout history, regardless of time or place or prevalent fashion, is to him moral treason.

*Jean Renoir, *Renoir, My Father* (Boston: Little, Brown), 1958, pp. 6, 32, 165.

I n 1971 Brandt wrote a volume for the Art in Practice series published by Van Nostrand Reinhold. Called *Painting with Oils*, it is "as unlike a 'how-to-do-it book' as I could make it." Brandt's own work is used throughout to illustrate his points, and there are numerous photographs of him at work. The result is a handsomely produced volume that is part instructive, part autobiographical, straightforward and succinct. It had considerable success in the early 1970s and went into a second printing.

The editor of the book, Jerry Bowles, introduced Brandt in his preface:

> The man and the artist are inseparable: Brandt is Southern grace wed to an intuitive sense of order. He is committed to the pursuit of his vision of the truth and to excellence in the grandest sense. . . .
>
> Brandt is probably the best painter of women alive; almost all of his paintings with figures are celebrations of the female form and mystique. . . .
>
> Brandt is a gentle bear of a man who enjoys life and people and art. In the creative sense, he is a restless man who is constantly refining his craft and sharpening the range of his imagination. . . .
>
> What Warren Brandt does best is oil painting, traditional easel painting developed out of the French tradition but updated and personalized. He is an artist's artist and his mastery of the intimist genre is simply unexcelled.

Brandt's own words are less hyperbolic. In his eleven one-page chapter introductions and his picture captions, he evinces the calm intensity and clarity of articulation that characterize his paintings themselves. What emerges is his patient insistence on order and his reliance on and understanding of the rules of his craft. We encounter someone who is at ease with the natural world—who feels no need to turn from it in the manner of, say, geometric abstractionists—but who at the same time wants to organize that world with precise rules and boundaries. His sensuous responsiveness is always cloaked in a certain formality. It is formality in the most literal sense of the word—dependence on form—rather than formality in the sense of artifice or historicism. In a century when many have chosen to revel in the confusion of the unconscious, here is the voice of one who deliberately opted for balance, for devices that add steadiness and measure. We sense his slow, even, deep breathing. He may have had a strong personal taste for Abstract Expressionism, but in his own work and, consequently, in his advice to others, the personal emotionalism, strong as it is, is tightly reined. He has clearly been driven to culture—a sense of the past; a desire to model aspects of one's self on chosen traits of the people of accomplishment whom one admires; a cultivation of one's skills and one's aesthetic instincts—in preference to the unfathomable sides of his own psyche. There is a prevalent calm, the by-product of his deep knowledge of himself and his goals, of his preference for the fathomable over the confusing. Rules, a sense of celebration, and patience all emerge from the pages of *Painting with Oils*.

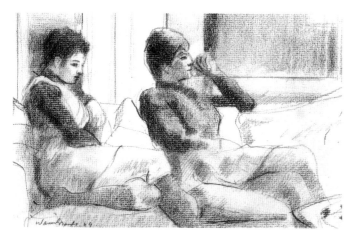

Lois and Barbara Jo
1969
pencil
5½ x 9 inches
Collection: Lois Borgenicht, New York, N.Y.

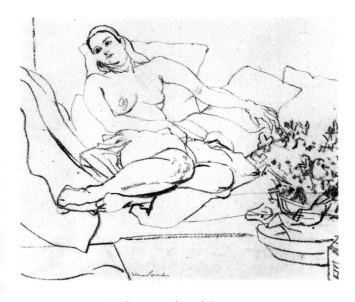

Reclining Nude with Bouquet
1970
conté chalk
10½ x 13½ inches

In addition to more theoretical points, the book offers some very specific instructions on how to go about the process of making art. Even the nonpainter finds himself surprisingly tempted to pick up a brush and put paint on canvas; Brandt makes the process irresistibly inviting—intuitive and spiritual at the same time. We feel as if the omnipresent sense of structure, of things flowing together, of harmony, will penetrate our very beings. It is as if the physical act of painting will fulfill spiritual goals that relate to our innermost personal longings.

Brandt demonstrates some wonderful traits in the text of *Painting with Oils*. He always takes upon himself the responsibility for what he is doing; here is someone who is never the victim. The man who says that life has been good to him and that he has had a lot of luck also takes charge. Brandt rolls with the punches and at the same time fights to win. The key is that he is constantly alert. He notices what is happening with a painting and is willing to make changes accordingly, rather than letting himself get stuck in a rut.

Throughout the book we have recurrent themes: the emphasis on responsiveness to change, the passion for fluidity and form. The clarity with which Brandt perceives his goals is rare, as is his sense of certain inviolate rules of painting—timeless, universal attributes that he wishes to articulate to students. He reveals a satisfaction with his own achievement, a knowledge of the success of his own work, that is essential to the noncomplacent serenity of both the man and his art. We leave the book feeling tranquil and nourished, as after any encounter with a sureness and certainty that are affirmative rather than arrogant, celebrative rather than judgmental.

The qualities that were first apparent in the 1965 *Blue Nude* and that reached a veritable apotheosis in the 1978 *Studio Interior with Model* are all consistent with the theories of his book and continue to characterize Brandt's work to this day. His most recent work is more intense, more faithful to the reality of appearances, than ever before, but the abiding concerns—timeless, in some ways traditional, utterly disconnected from art-world trends—remain.

The 1967–68 *Berta* (page 57) is an early essay in the strong sense of massing that marks the paintings of figures in interiors and has become increasingly intense over the years. Light suffuses the atmosphere, creating a warmth that seems to caress the sitter with the same sense of enclosure as her massive armchair. The warmth of that light becomes spiritual as well as physical; we feel Berta's inner glow in every sense of the term, and it is contagious. Similarly, in the 1971 *Two Models in Green* (page 58) the ease of the pose sums up the aura of the entire painting. (This aura of relaxation is impressive to Brandt some fifteen years later. Viewing the painting recently, he remarked that he wished he "could achieve that lightness now; now I'm painting heavy.") The flowers throughout *Two Models in Green* add their grace and

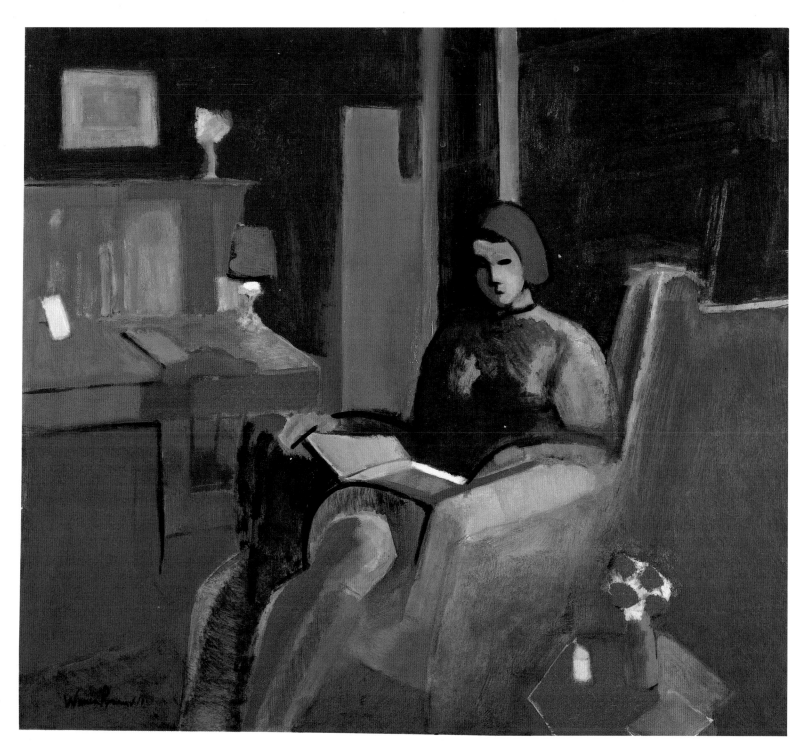

softness to the whole. The monochromatic picture space reflects to a degree Brandt's love affair with Matisse; so do the subject matter and rich patterns of the 1971–72 *Michelle* (page 59). Brandt has clearly gained a great deal from Matisse, but without resorting to imitation. He is happy to acknowledge the influence of Matisse's feeling for certain subjects and for the role of color, while explaining that "Matisse is too brilliant to be copied. . . . I paint girls in

Berta
1967–68
oil on canvas
36 x 40 inches
Collection: Dr. and Mrs. Arnold D. Kerr, Wilmington, Del.

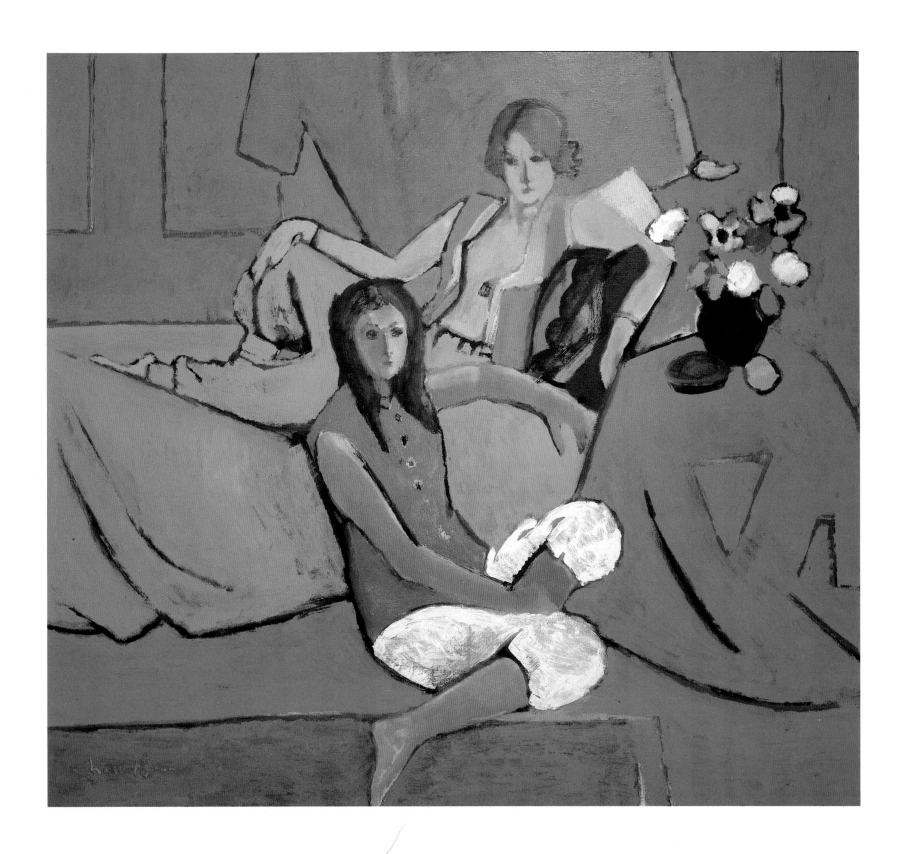

58

Two Models in Green
1971
oil on canvas
53 x 59 inches
Collection: Ciba-Geigy Corporation,
Ardsley, N.Y.

Michelle
1971–72
oil on canvas
30 x 26 inches

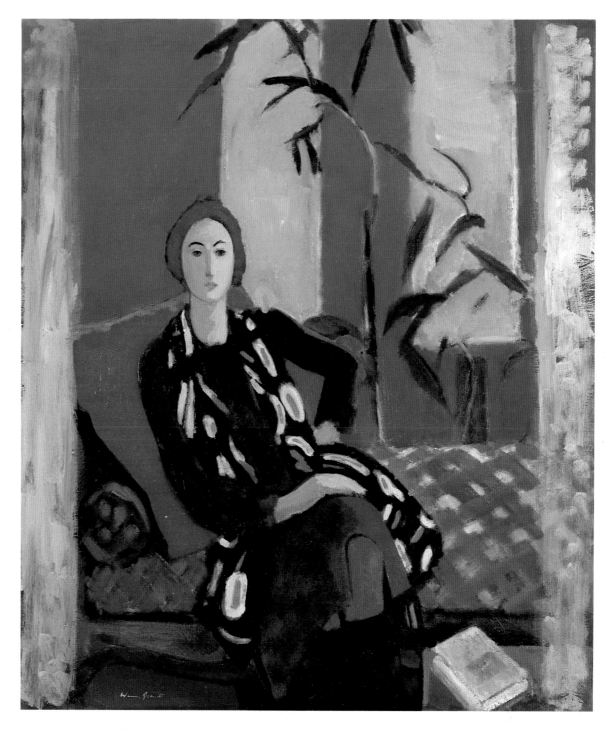

harem pants with robes around them, and that makes it like Matisse to some people, but Delacroix did it before Matisse. It's just a wonderful subject." The 1977 *Model on Black Caftan* (page 60) has in even greater profusion the warm sensuousness of the earlier canvases; the charms of the Venus-like figure are nicely augmented by the rich pink-green-orange play of the background. This painting anticipates the more elaborate *Studio Interior with Model*.

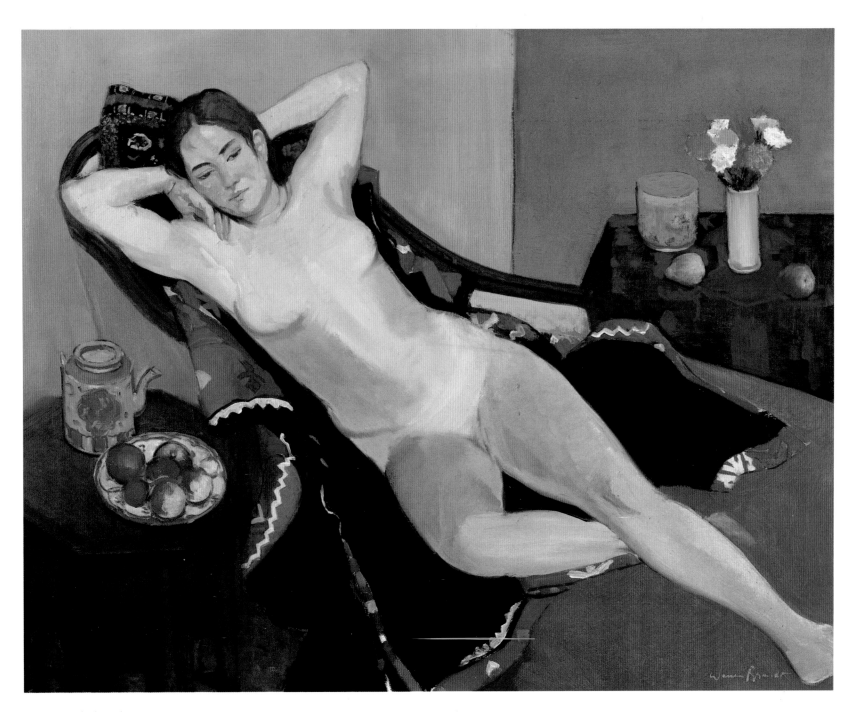

Model on Black Caftan
1977
oil on canvas
30 x 38 inches

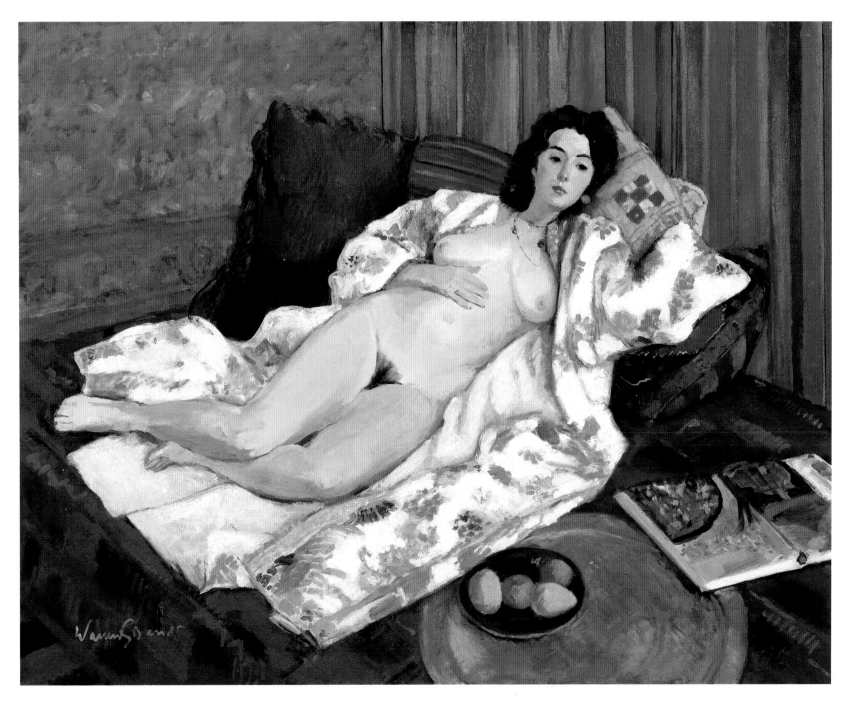

Shirin
1978
oil on canvas
29 x 36½ inches

Two Sisters
1977
charcoal and chalk
12 x 13 inches
Collection: Jan Schwartz, Los Gatos, Calif.

Nude with Flowers
1977
charcoal and chalk
9 x 16 inches
Collection: Lois Gerson Kushner, Bala Cynwyd, Pa.

Seated Nude
1977
charcoal and chalk
16 x 9 inches
Collection: Mr. and Mrs. Stanley
C. Tuttleman, Merion, Pa.

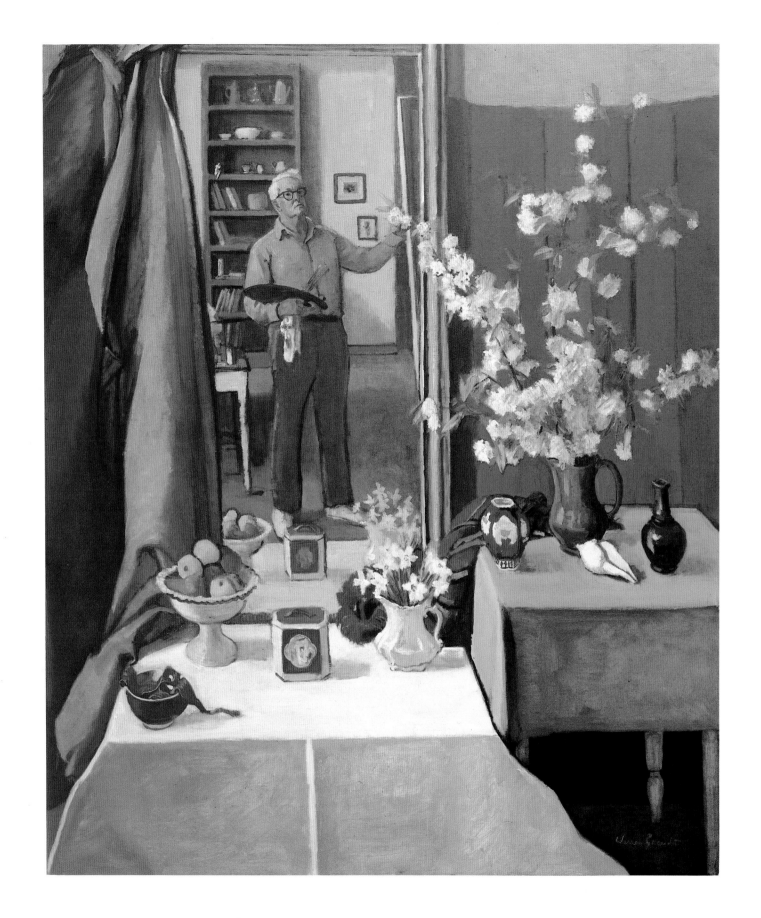

Self-Portrait in Studio
1982
oil on canvas
60 x 50 inches
Collection: National Academy of Design,
New York, N.Y.

Self-Portrait in Morelos
1980
oil on canvas
35½ x 27½ inches

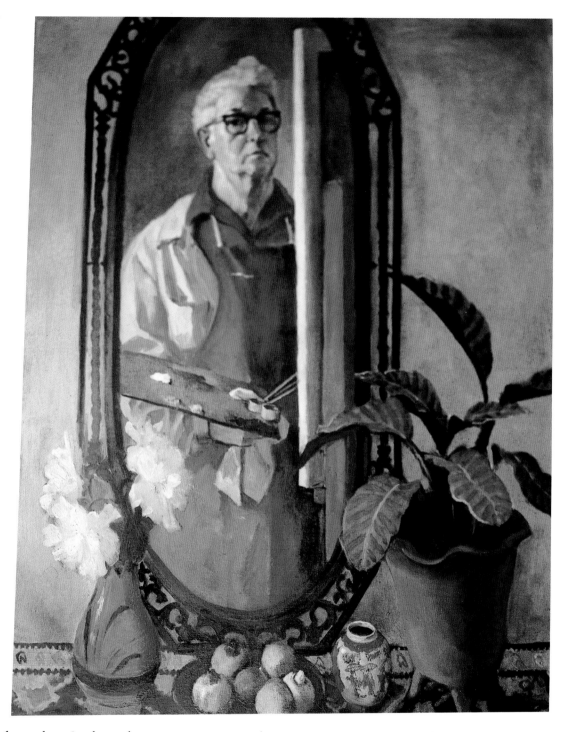

The self-portraits (pages 64 and 65) of the early 1980s have the same compositional richness of the 1979 canvas in the collection of the Metropolitan Museum (page 10). These paintings are as much still lifes as self-portraits, and it is the area of still life that Brandt has explored most tenaciously in the past two decades. *Blue Still Life* of 1970 (page 69) resembles both the 1965 *Blue Nude* and the 1971 *Two Models in Green* and reflects many of the same concerns. With their playful combinations of flatness and depth, these paintings

Studio Interior with Model
1977–78
oil on canvas
60 x 108 inches

Red Still Life
1973
oil on canvas
36 x 40 inches
Collection: John Williams, Tulsa, Okla.

Snapdragons
1973
oil on canvas
60 x 48 inches
Collection: Mrs. Shirley Kash, Westport,
Conn.

all offer rich, broad expanses of color. The brushiness that dominated Brandt's earlier interior paintings is now confined to details. The homogeneity of the surface imparts a tranquil serenity. The articulation of the table top through a few scratchy lines is as quiet and gentle as possible. The more we look, the more we as viewers imagine the pleasure of making this glistening, pretty painting. We begin to share the artist's perceptions of all the arrangements—of flowers, of the objects scattered on the tabletop, of solid against void, and of blue and white played against one another in myriad ways.

Brandt's still lifes became increasingly complex in the early 1970s. In *Still Life with Mums and Carnations, Snapdragons, Red Still Life, Still Life in Red Room*, and *Exotic Still Life* (pages 2, 66–68, and 70), there is a new richness of pattern effects within elaborate compositions that present a virtual panoply of objects. The effect in each case is of opulence, an opulence devoid of vulgarity because it is so clearly the manifestation of skill and discipline. *White Table, Black Chair* of 1977 (page 74) and *Empire Chair* of 1978 (page 76) belong to the same group as the 1979 *Tulips, Lilacs, and Dogwood* (page 75). Now the

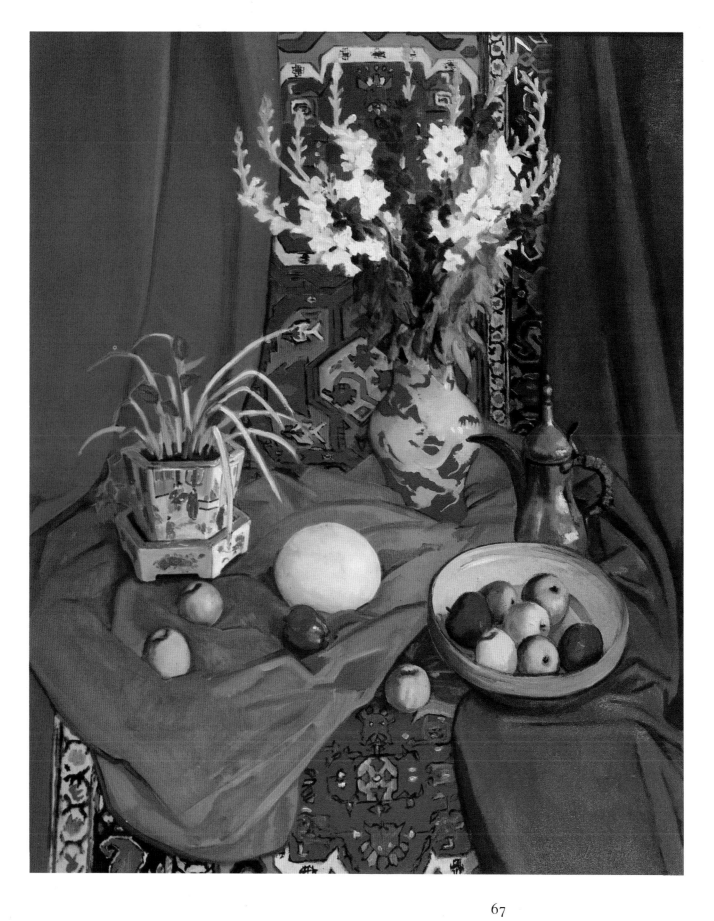

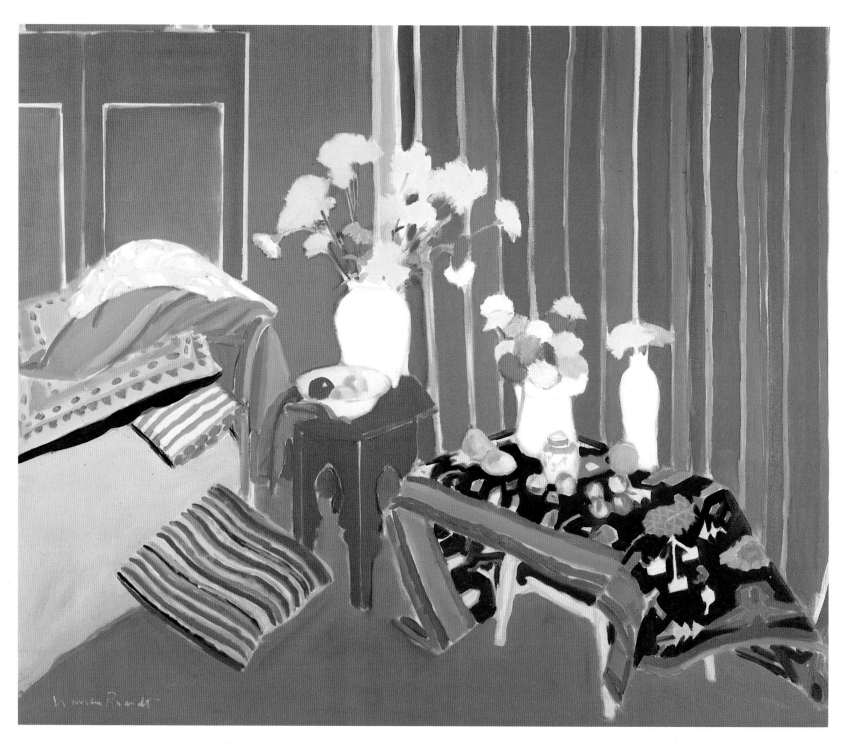

Still Life in Red Room
1972
oil on canvas
50 x 60 inches
Collection: Lois Gerson Kushner, Bala Cynwyd, Pa.

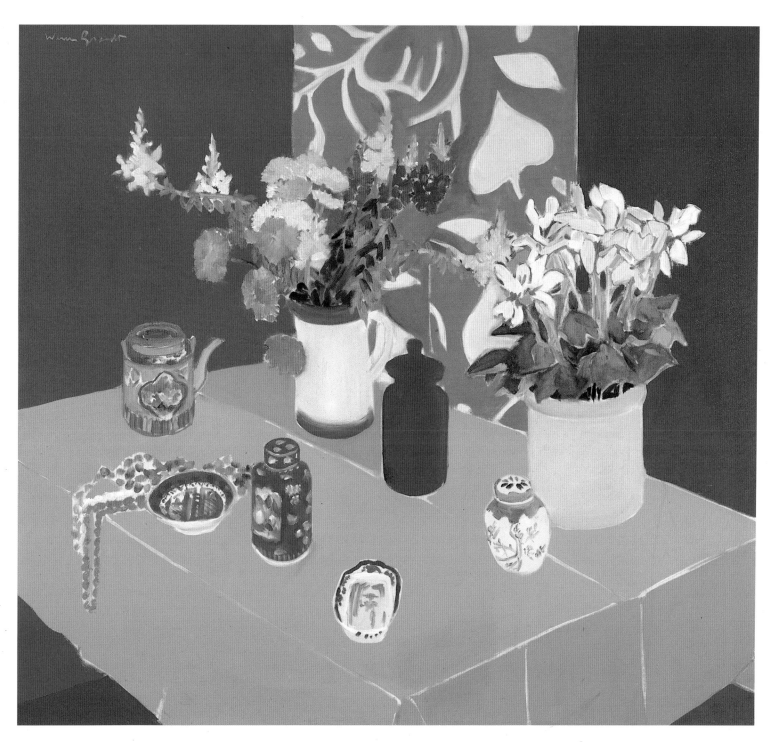

Blue Still Life
1970
oil on canvas
48 x 52 inches
Collection: Jan Schwartz, Los Gatos, Calif.

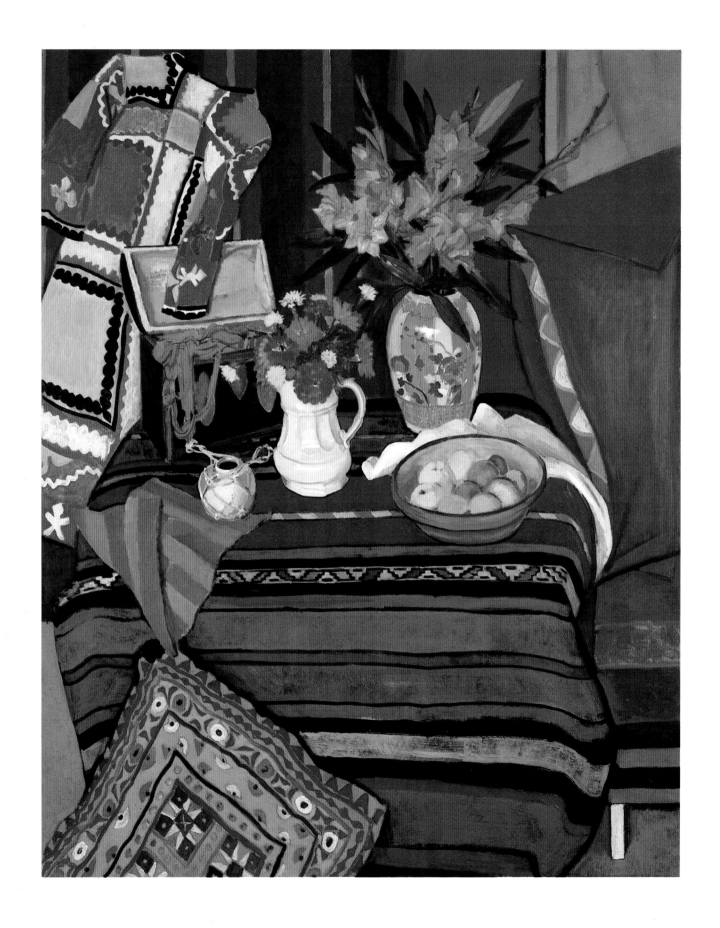

Exotic Still Life
1974
oil on canvas
60 x 48 inches

Oriental Still Life
1975
oil on canvas
68½ x 48 inches
Collection: Steve and Kathy Rosenberg,
New York, N.Y.

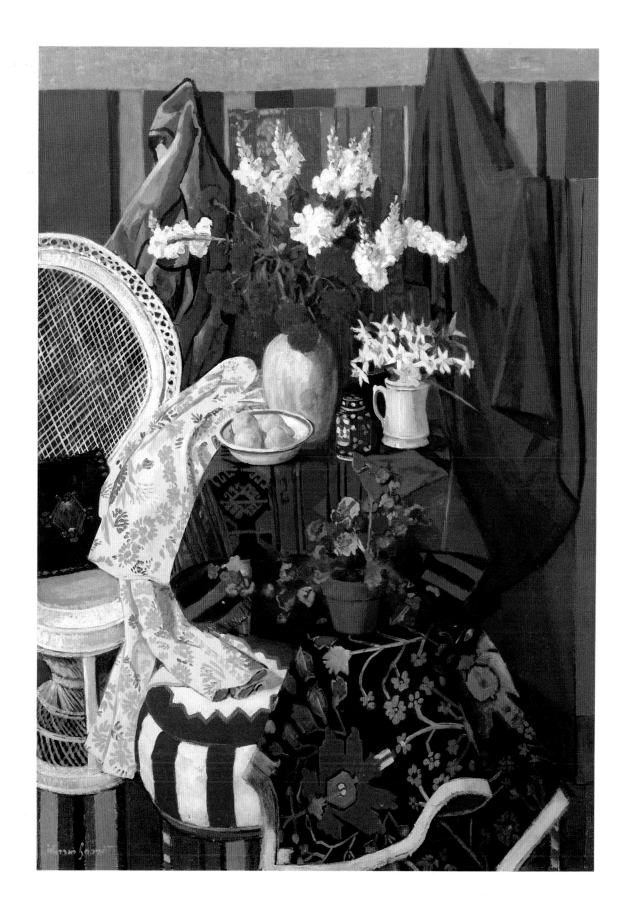

Warren Brandt, 1984

sense of plastic reality, of real sculptural presences, is even stronger. The tables and chairs have palpable weight. There are still patterns against patterns, but the interest in surfaces —both the surface of the canvas itself and the ornament on rug, drapery, and pillow—is less strong. Massing has become the vital issue; the objects, even a drapery thrown on a chair, have a new monumentality. We feel the magnificence of matter and of gravity. We think about folds: what happens to the air within them, the suppleness of certain materials against

the rigidity of others. The compote dishes and vases of flowers that Brandt has long been painting as the lovely details of everyday living now have a real grandeur to them. Space is more definite than before. We no longer have a monochrome of floor and two walls; now the issues of floor and wall, the sense of enclosure and spatial framing, have a new seriousness. Our eyes move back and forth through these spaces, around the objects, in and out of wooden scrollwork. Things really sit there. The sort of everyday reality that Brandt approached rather tentatively and lyrically in the early 1970s has new profundity and power. *White Table, Black Chair* is a painting that, while almost too big a statement to deal with easily at first view, offers more the longer we look. The movement around objects and through space is perpetual. We really feel the air behind the big chair; we feel with certainty the weight of the porcelain vessels on the white tablecloth. Brandt's articulation of gravity and space convinces us completely. We enjoy the pulsing force of the lively rhythms; we are invigorated by the boldness of the colors; and at the same time we feel with total assurance the reality of the subject matter.

White Table, Black Chair hangs in the Brandts' living room in Water Mill, along with *Blue Still Life* and *Tulips, Lilacs, and Dogwood*. The artist's response to the paintings today is as candid and straightforward as the paintings themselves. "I sit here and I look at these paintings and I wonder how I ever came to such balance. They may not be great paintings, but they work. The pictures stay there. The forms sit, yet the relationships, and emphasis, constantly change. Each time you look you see a different order. If a picture works, you can find movement in it forever. If it doesn't work, it is very disturbing—it's static, and it's out of balance. Whether it's realistic or abstract is beside the point." This issue of simultaneous movement and balance is, in fact, not only one of the major goals of Brandt's art, but also a metaphor for his entire life with its combination of hard labor in the studio and an existence in which family, recreation, and the joys of daily living all have their place.

The 1979 still life *Japanese Print and Pink Roses* (page 77) was bought by the novelist Irwin Shaw and his wife. Shaw wrote about it in 1982, for the catalogue of an exhibition that Brandt had at the Fischbach Gallery in New York early the next year:

> There is a painting by Warren Brandt that hangs over the fireplace in the living room of my home. It is a still life of flowers and fruits, all forms and colors so luminous in brilliant sunshine that even on the gloomiest November afternoon the painting bequeaths a warm glow to the entire room. Here, one knows, is the work of a robust and hearty man, but with a delicate and sure touch to refine his physical abundance. It is the work of a man who is happy to be alive, delighted with what his eye observes, with the arrangements his hand makes, the fold of a cloth, the spike of bright color against a dark print on a wall. The same sense of delight pervades all his canvases, still lifes, nudes, landscapes, putting the painter's mark on every brush stroke.
>
> He is not an experimenter. There is no agonizing, no distortion in an attempt to be new. He is a celebrator, content to use traditional means and

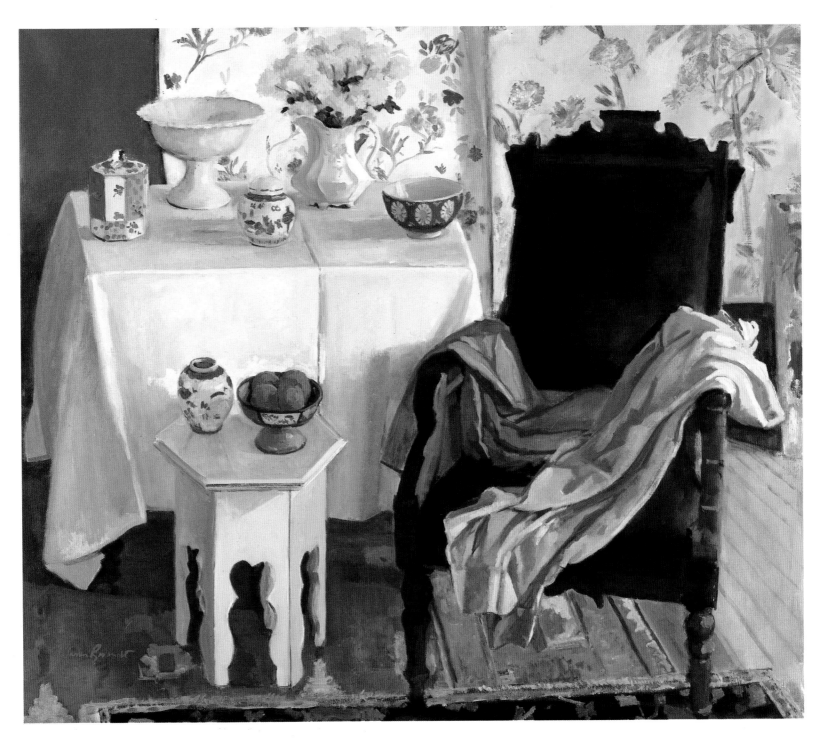

White Table, Black Chair
1977
oil on canvas
38 x 44 inches
Collection: Lois Borgenicht and Johannes
Reim, New York, N.Y.

Tulips, Lilacs, and Dogwood
1979
oil on canvas
60 x 56 inches
Collection: Isabella Brandt, New York, N.Y.

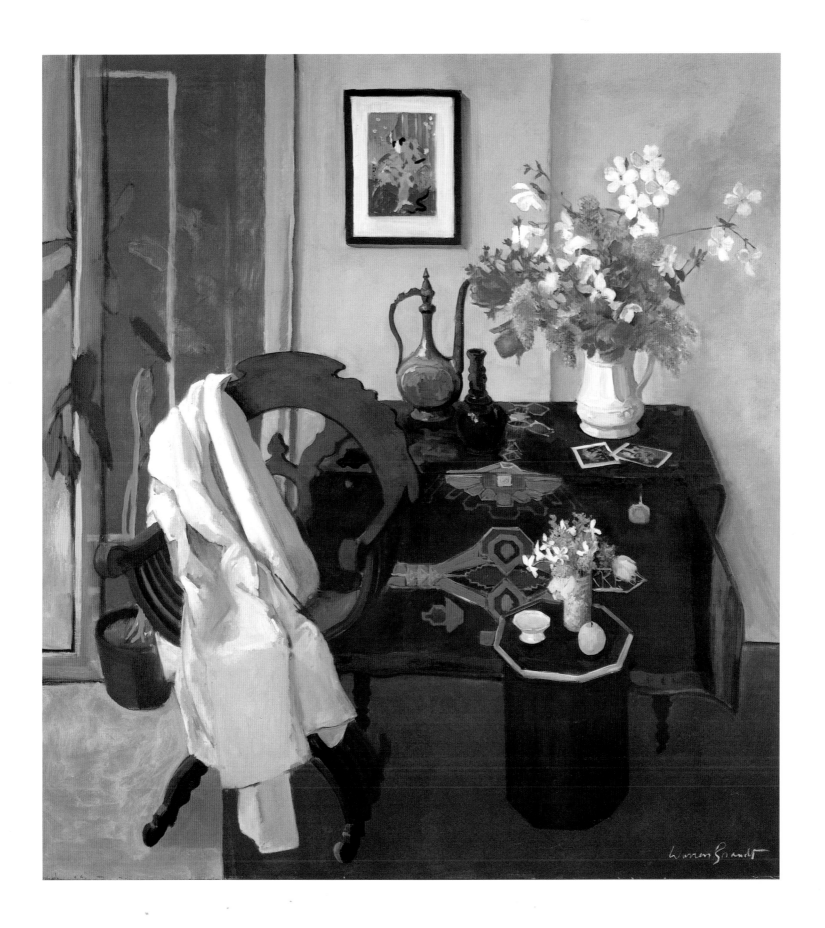

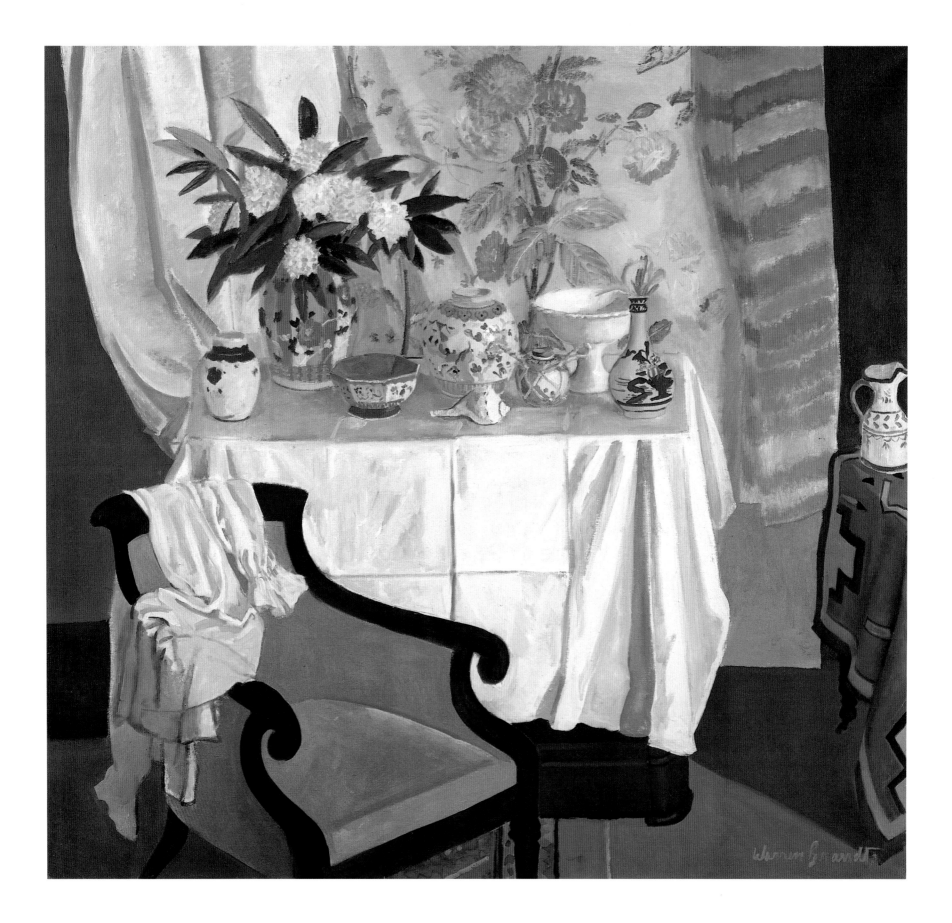

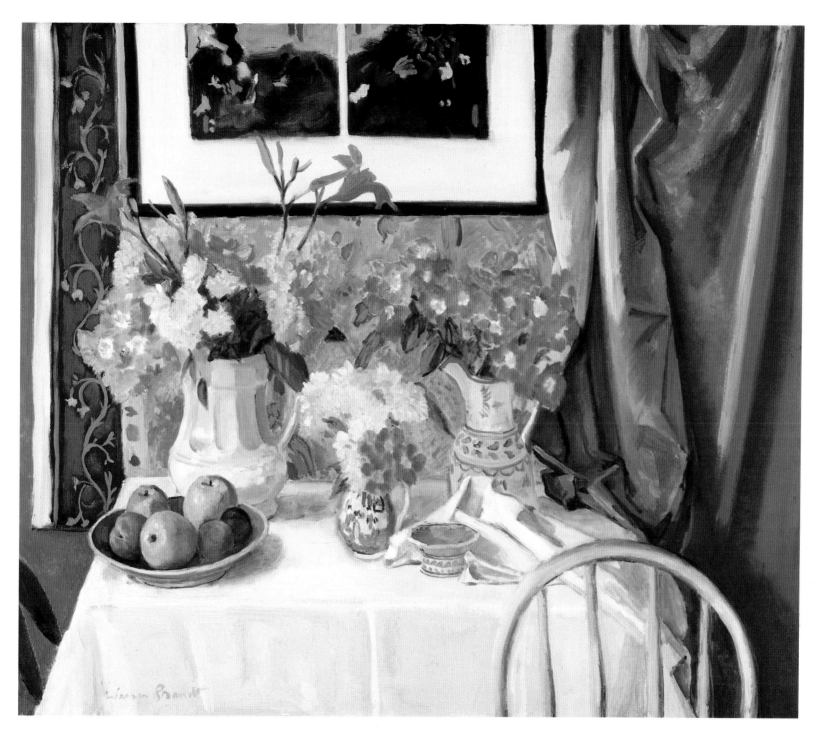

Empire Chair
1978
oil on canvas
56 x 60 inches
Collection: Grace Brandt, New York, N.Y.

Japanese Print and Pink Roses
1979
oil on canvas
34 x 40 inches
Collection: Mrs. Irwin Shaw, Klosters,
Switzerland

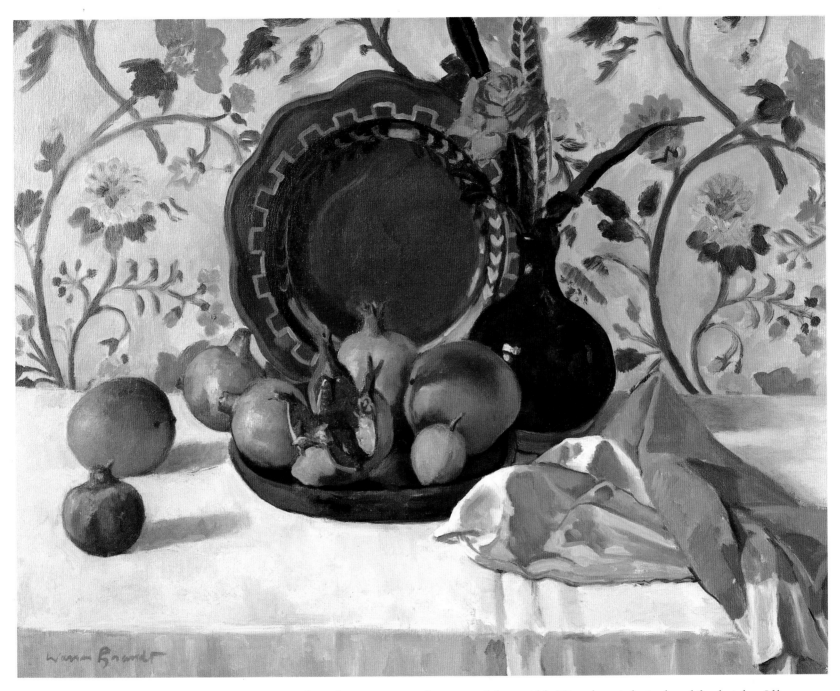

Mexican Plate and Pomegranates
1981
oil on canvas
21 x 28 inches

disciplines to give us his view of the world. His talent is lyrical and forthright. If he were a poet instead of a painter I could imagine him as a writer of sonnets, not constricted by the regular cadence and rhyme scheme, but using the form to speak directly and familiarly to us, to share his emotion with us without fear of being misunderstood.

Who has not known a dark November afternoon, whose shadows would have been reassuringly illuminated by the glow emanating from the paintings on these walls?

Some of us see Brandt's work as the product of more of a hard-fought effort than Shaw suggested. There is, in fact, some agonizing; it just does not surface in the end results. But what the novelist conveys of the impression made by Brandt's finished art is entirely valid. If, in fact, quite contrary to Shaw's inference, there have been defeats as well as victories along the way, it is true nonetheless that "a sense of delight" is at the essence of Brandt's art. He offers a calm, the feeling of having found answers. There is a simple goodness here, an old-fashioned (in the best sense of the term) comfort. There is, somehow, something very American about the straightforward, unequivocal presentation, and at the same time we feel a quintessentially French sense of comfort and luxury. That is all perfectly appropriate for the son of a Southern cotton merchant who says, "All my life I've been in love with Matisse."

From the mid-1960s to the present Brandt has had, with only a couple of exceptions, anywhere from one to three one-man shows a year. A. M. Sachs continued to represent him in New York until 1975; in 1977 the Fischbach Gallery, where he currently shows, took over. Hooks-Epstein Gallery in Houston has shown him twice, and the David Barnett Gallery in Milwaukee and the Fontana Gallery in Philadelphia have shown him repeatedly. There have also been retrospective exhibitions in museums, including the Weatherspoon Art Gallery in North Carolina, the Allentown Art Museum in Pennsylvania, and the Beaumont Art Museum in Texas. The reviewers—John Canaday and Hilton Kramer among them—have written favorably. His work has also been included in numerous group shows, at such places as Guild Hall in East Hampton, New York, the Corcoran Gallery in Washington, D.C., and many private galleries with an emphasis on figurative work. A number of critics have singled Brandt out in their reviews of these larger exhibitions. In addition, the work has sold well. Brandt's art has never been the hot fad everyone is talking about, but it has enjoyed a constant level of continuous support. It succeeds in uplifting the people whose values are its values. For the artist himself, there has been a not unusual combination of assurance and longing for reassurance—the certain knowledge of how he wants to paint along with a natural need for others to believe in him. It is the sureness—the faith and the know-how —that most certainly survives in the paintings.

From 1980 to 1983 the Brandts spent four months a year in Mexico. All the painting Brandt did there has a distinct palette, a bit earthier and more muted than that of his New York or Long Island works. A rich terra-cotta tone dominates the 1981 still life *Mexican Plate and Pomegranates* (page 78). The flowers— both real and on the wallpaper—are a dusty rose; the vase, the chocolaty brown of certain Mexican hand-blown glass. The deep, shiny auburn tone of the inside of the pomegranates plays against their muted peach and red exteriors. These colors give the work a mood, a spirit of combined monumentality and

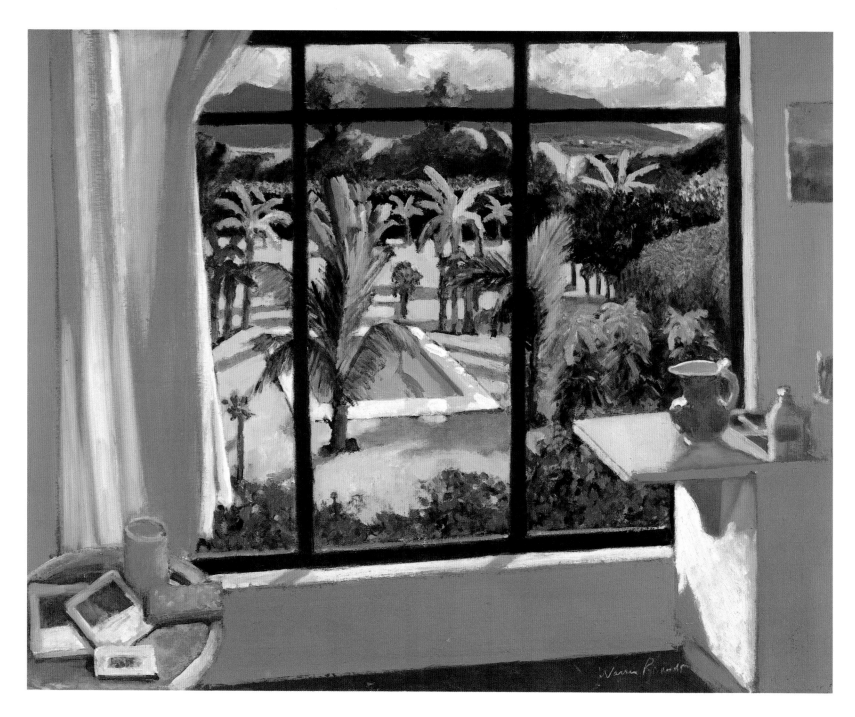

Dr. Marin's Garden
1982
oil on canvas
54 x 74½ inches

serenity. The Brandts' house was not far from a brick kiln, and that, along with the local soil, may have affected the hues considerably.

Dr. Marin's Garden of 1982 (page 80) is a particularly interesting composition dominated by the grid of large window panes. While showing the glass only by implication, Brandt establishes the distinction between inside and outside with total clarity. There is a boldness to the canvas. We feel the artist's confidence in his own judgment about what he likes to look at and precisely which elements of it he wants to present. There is nothing tentative about the approach here, either to the big rhythms or the smallest palm leaves. Brandt exalts the power of both the landscape and his own competence. The prevalent themes are those we know from his entire body of work: good weather, rich sunlight, a knowable world. This is an untroubled but multifaceted art, whatever may have been involved in the processes through which it was achieved.

Mexican Landscape with Brick Kiln and *Cocoyoc and Mountains* of 1983 (pages 82 and 83) are two of Brandt's richest canvases, in terms of both the color harmonies and the constant play of form. In *Cocoyoc and Mountains* we feel the thick, knowing brush; we feel the mass of the mountains. Brandt has no hesitancy in pushing a dark green mountain between a cloud-covered one and the nearer straw-colored hills; he makes his forms exist just where they should in space, and he moves easily between sharply contrasting shapes and hues. *Mexican Landscape with Brick Kiln* shows the view from his rooftop studio. Striped fields are played against broad paths, dark scrubby trees against paler, fluffier ones. Like all of Brandt's work, the canvas is entirely filled, worked right to the edges, and as a result it is very filling to the viewer. With all of these landscapes, we are reminded that we are looking at only *part* of a scene. Yet even if it is just a segment of life, it is organized in a rather formal, compositional way, full of balance and discretion. It is luxuriant, but not cluttered. It is as carefully cultivated, and yielding of value, as the plowed fields of rice it illustrates. With their rather muted palette and subtle progressions, the Mexican works are a realm of their own in Brandt's pleasure-laden world.

The work of the 1980s has the structure, the insistent loveliness, the constancy of rhythm of Brandt's earlier work; it has just become more intense. More than ever, Brandt achieves the reality of appearances. What he previously cherished he now positively exalts: the physical fact of an open book, of flowers in a vase. What a carefully crumpled tablecloth can conjure as a revelation of earthly reality—three-dimensionality, the displacement of air, the pliability of textiles—and as a vehicle for visual movement and counterpoint, gives it a monumental significance in Brandt's recent paintings. Warren Brandt is one of those artists who hasn't been seeking new truths so much as returning time and again to the miracle of old truths and trying to take them farther. Objects on a table have become both his essential reality and his source of enchantment. Flowers, richly patterned fabrics, ornate porcelain, pieces of fruit have become his gods and goddesses. It's not unlike Cézanne and those views of Mont St. Victoire, Morandi with his bottles, Albers with his squares of solid colors: artists who found the vehicle, but never tired of the realm to which it could lead.

His outlook is just as it was when he wrote *Painting with Oils*, only all the more definite. "What an artist is: he's someone who goes into his room and works hard. If you're good, you

Mexican Landscape with Brick Kiln
1983
oil on canvas
20 x 28 inches

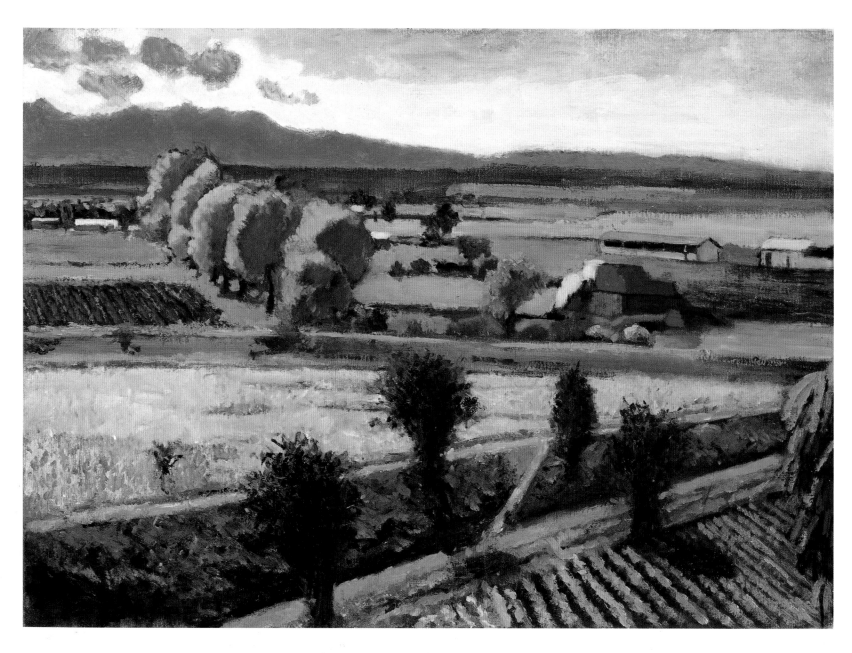

Cocoyoc and Mountains
1983
oil on canvas
42 x 50 inches

Model in Studio
1981
charcoal and white chalk
12 x 16 inches

stay in that room." In a world where artists spend years courting critics and entertaining curators, his comments on his own work offer the same insistence on fact, and avoidance of fudging, as the work itself; he'll say things on the level of "That's the view from the studio. Light is tricky. Indoor light is different from outdoor light." If he praises one of his own pictures, we do not feel that he is praising himself, but rather that he is like a craftsman praising a job well done, remarking on the materials and the way the task has gone as if he is serving forces greater than himself: "I love that picture—it's so flat. . . . That one over there grows on me; it's actually a good painting, and Grace likes it, too." His mind is not on current trends so much as on issues of real quality: "What I like about Renoir is that sculptural quality—the same as in Rubens." He makes judgments, but never justifications (rather extraordinary that is, these days): "I think the work either stands for itself or it doesn't."

A recent nude, the 1985 *Nude on Chaise* (page 85), conjures thoughts of Balthus in its rhythms and the twisting of the central figure, with her haunting, blatantly erotic pose. The brushwork in places reminds us of Brandt's work twenty years ago; the play of diamonds, curves, and stripes in and out of a lively yet carefully constructed space is something that we have seen before but that is now sharper than ever. The unhesitant, cheerful colors are like a rebuttal to both the understatement of much contemporary American realism and to the stridency of Neo-Expressionism. Brandt's recent still lifes are decisive, engaging, and clearheaded. They are visually charming at the same time that they are profound and complex. In their colors and forms, the rendering of space, the play of lights against darks they offer vast pleasure.

Brandt is one of those people who has grown increasingly warm and tender with age; not that his work at any point revealed cynicism, but now the heartfelt ardor and buoyant spirits are in fuller force than ever before. He has said that the desire, evident in these paintings, to get "something that's heavier and solider" makes him feel at times as if he is "in reverse gear. But I love it." There are more volumes, a heightened visual clarity. Brandt addresses the realities of the material world without any ambivalence and without gratuitous comment. He wants the certainty of the known. Conservative in one sense—in the traditional nature of some of his goals—he is on another level a contemporary radical, obsessed with some ancient issues of painting that show no regard whatsoever for current trends or timeliness in painting styles. What moves him is his ever-increasing passion for earthly reality—the beauty of female flesh, exotic drapery, flowers in an attractive vase —and for a sense of the power of matter to convey some of the miracles of earthly life and the achievements of culture.

Like the Impressionists in one way and the Cubists in another, Brandt is after a sort of truth: truth in the encapsulation of spaces and objects; truth in the creation of pictures that have, in their formal and color qualities, a completeness and artistic rightness. We see a system of painting; we see an organization of the canvases that is like the organization of the places in which he works—efficient studio spaces designed to make the tools of his craft, and the uninterrupted effects of his subject matter, as accessible as possible. We see the way light hits objects; we see the way the painted canvas can offer a sense of the finite and graspable. Our eyes keep moving along a course of oriental shawls and Persian rugs, yet there is

Nude on Chaise
1985
oil on canvas
24 x 36 inches

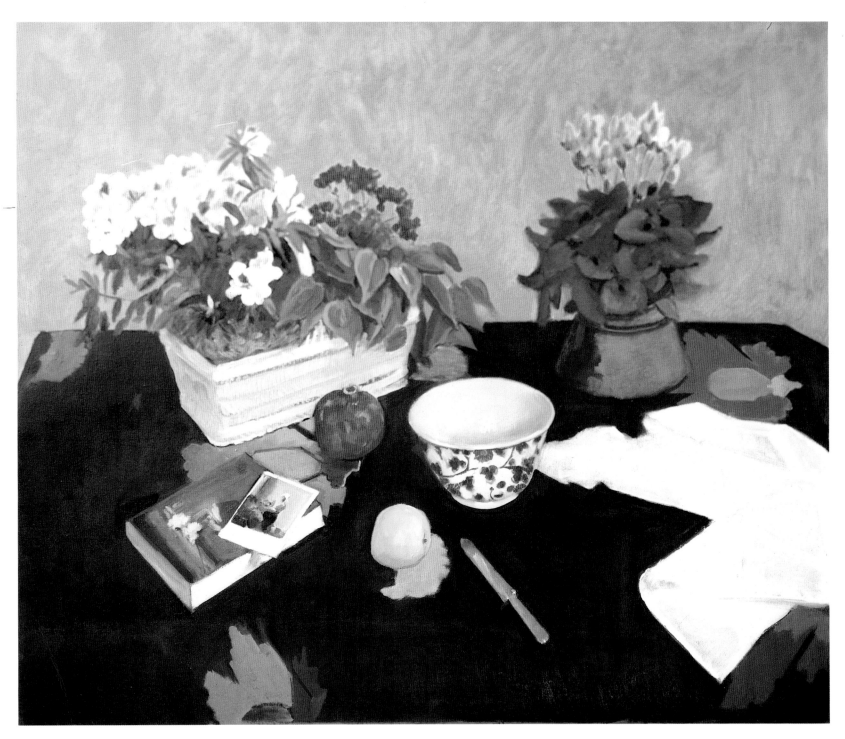

The Basket of Flowers
1982
oil on canvas
42 x 50 inches
Collection: Mr. and Mrs. Roger Weiss,
Rye, N.Y.

Still Life with Hat
1983
oil on canvas
50 x 42 inches

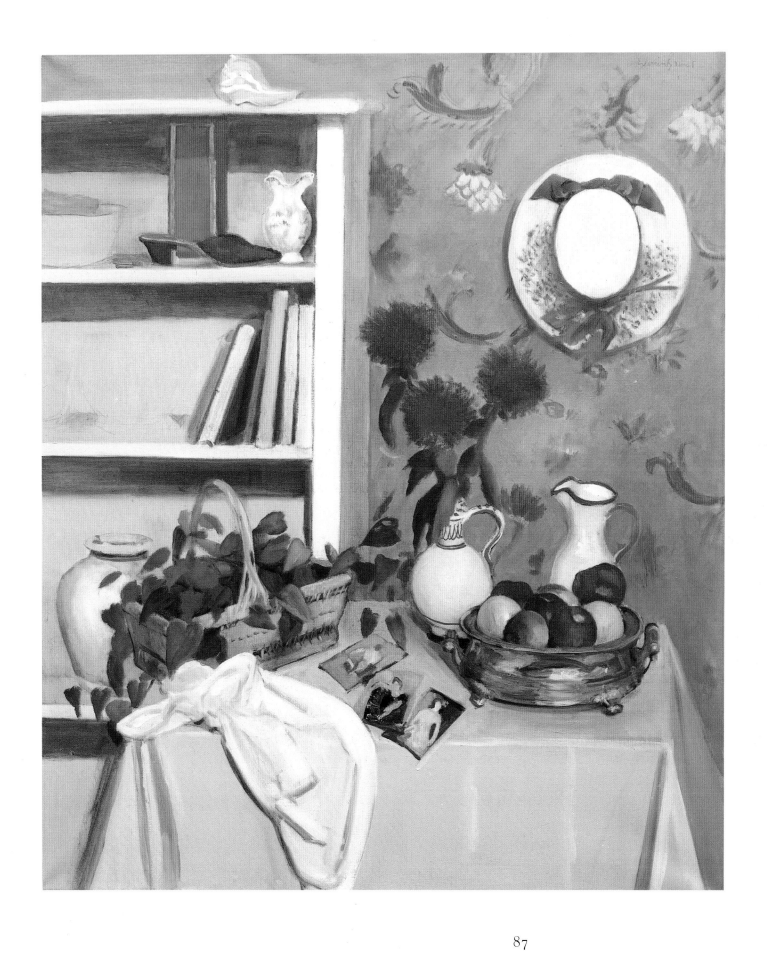

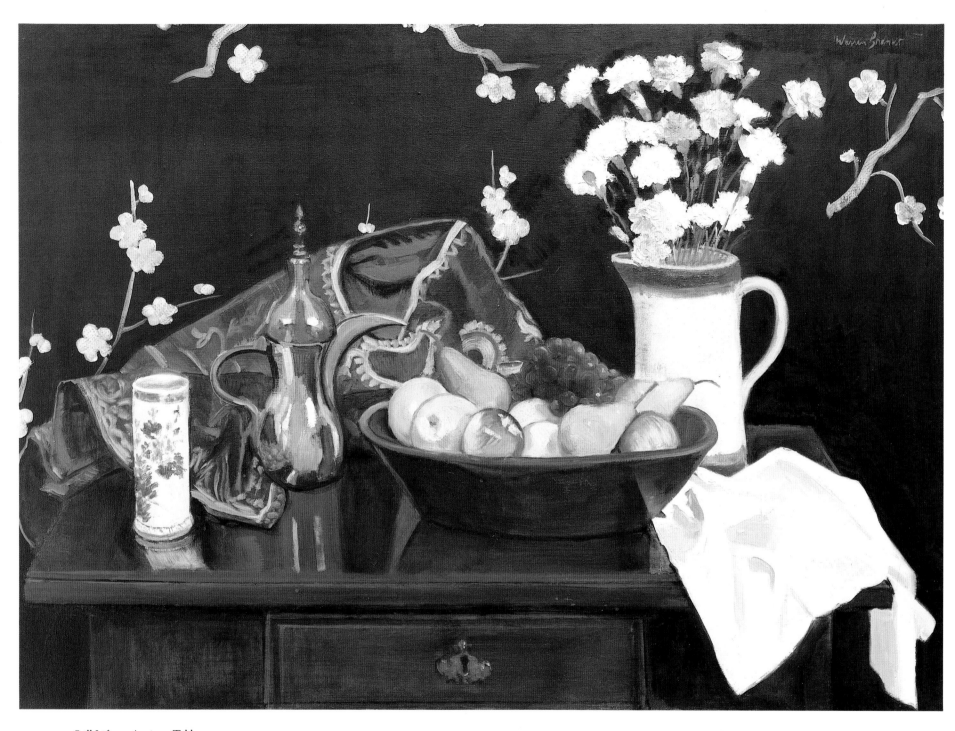

Still Life on Antique Table
1984
oil on canvas
32 x 44 inches
Private collection, Nashotah, Wis.
Courtesy: David Barnett Gallery,
Milwaukee, Wis.

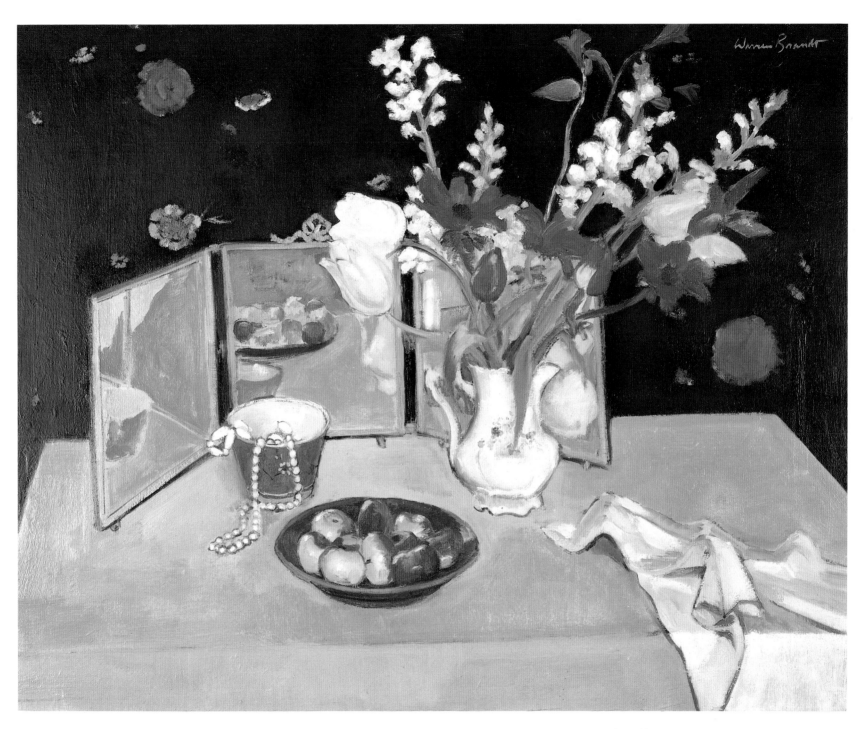

The Folding Mirror
1984
oil on canvas
30 x 36 inches
Collection: David Garvey, Austin, Tex.

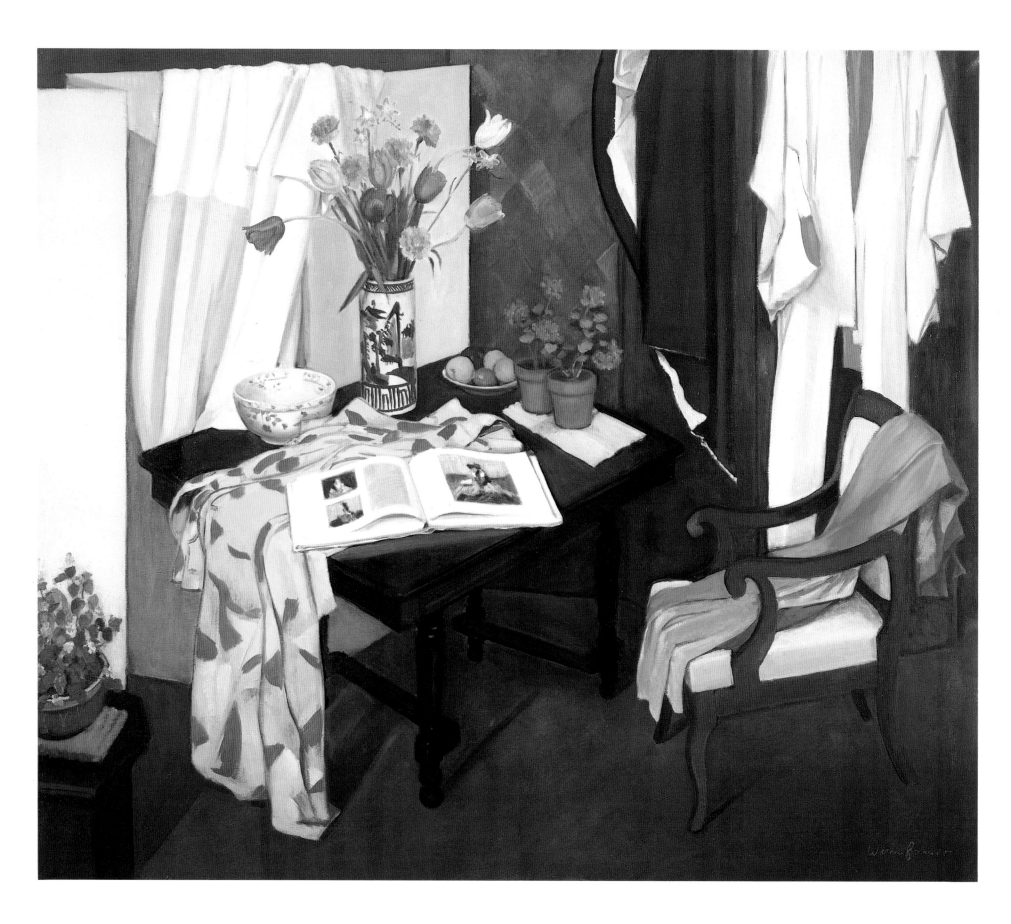

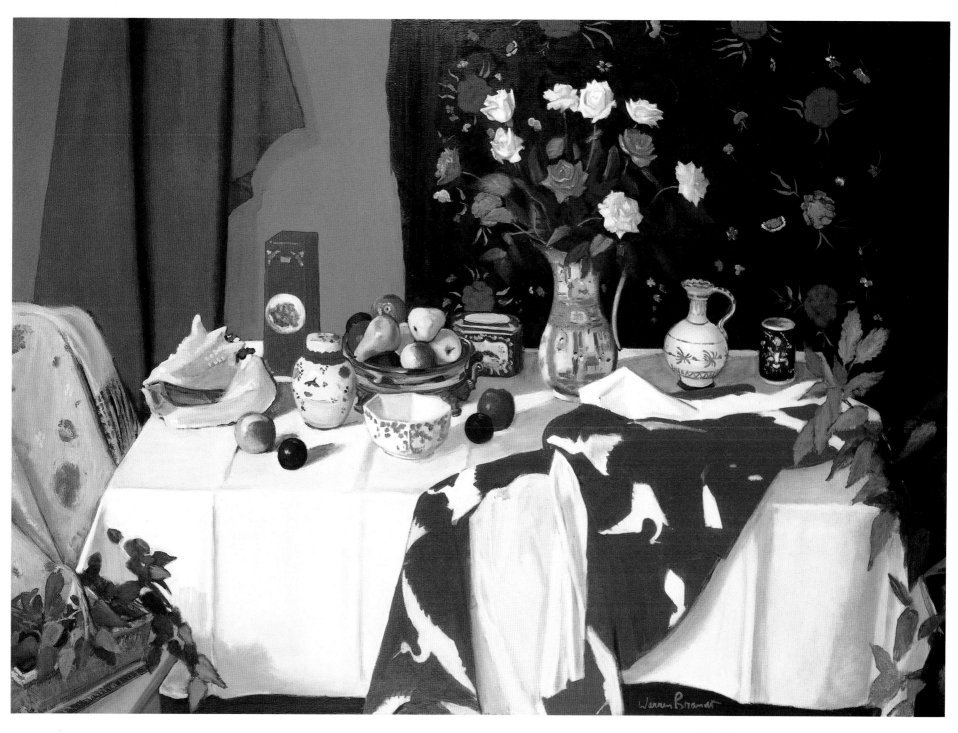

Open Book with Japanese Kimono
1984
oil on canvas
60 x 70 inches
Collection: Richard Lippe, New York, N.Y.
Courtesy: Vered Gallery, East Hampton, N.Y.

Roses and Red Kimono
1985
oil on canvas
51⁵⁄₁₆ x 72⁵⁄₁₆ inches
Collection: Museum of Art, Carnegie
Institute, Pittsburgh, Pa. Gift of Margarete
Schultz and Benedict I. Lubell, 1985

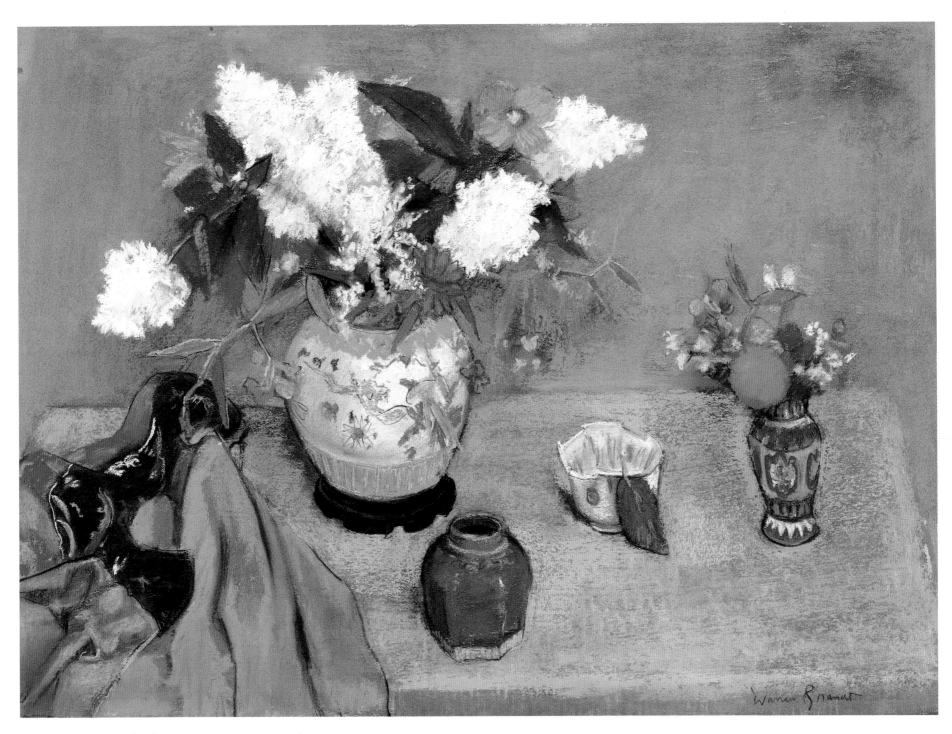

Chinese Still Life
1985
pastel
24 x 32 inches
Collection: Mark and Angel Joseph,
London, England

always an ordering of the exotic, a sense of riches each in its own place. We feel Brandt's desire to extract as much beauty, charm, and richness as possible from the subject—and at the same time his wish to impart as many of those qualities as possible *to* the subject. There is an intensity to the work; it reveals a direct, unhesitating confrontation with skin and fabrics, with the issues of form and shape—a full-fledged, winner-take-all embrace.

Poinsettias with Fan
1986
pastel
22½ x 26½ inches
Collection: Mrs. Helen Deitz, Wilmington, Del.

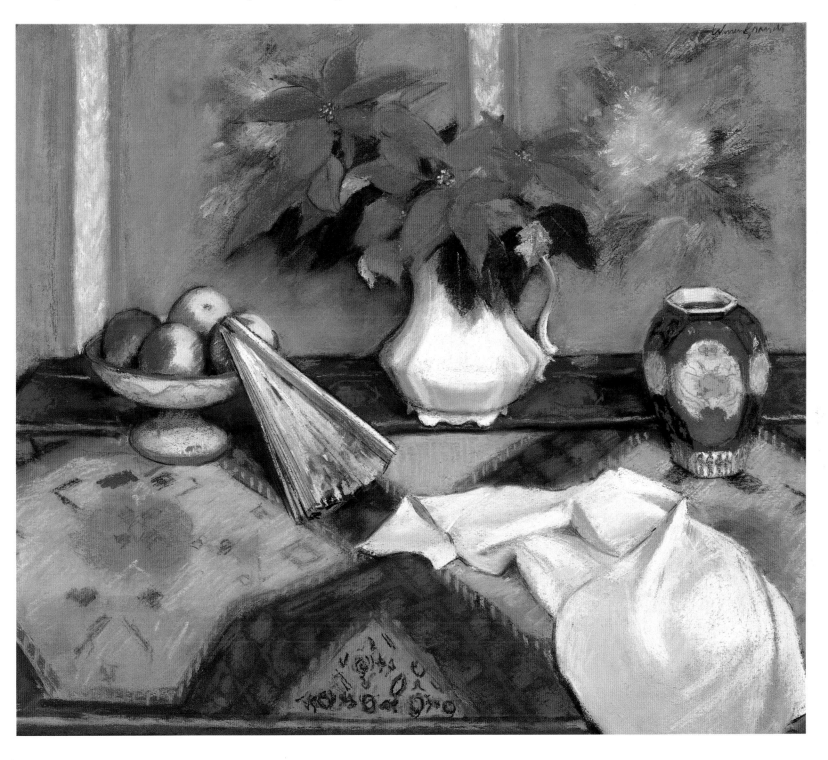

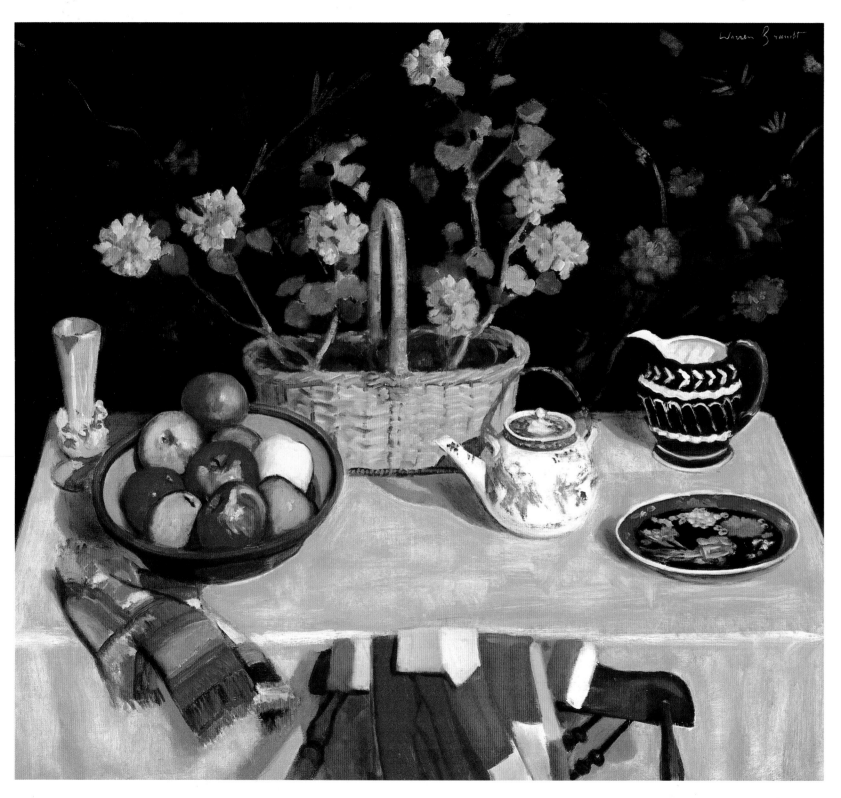

Geraniums and Blue Tablecloth
1985
oil on canvas
36 x 40 inches

Chinese Blue Vase
1986
oil on canvas
50 x 40 inches

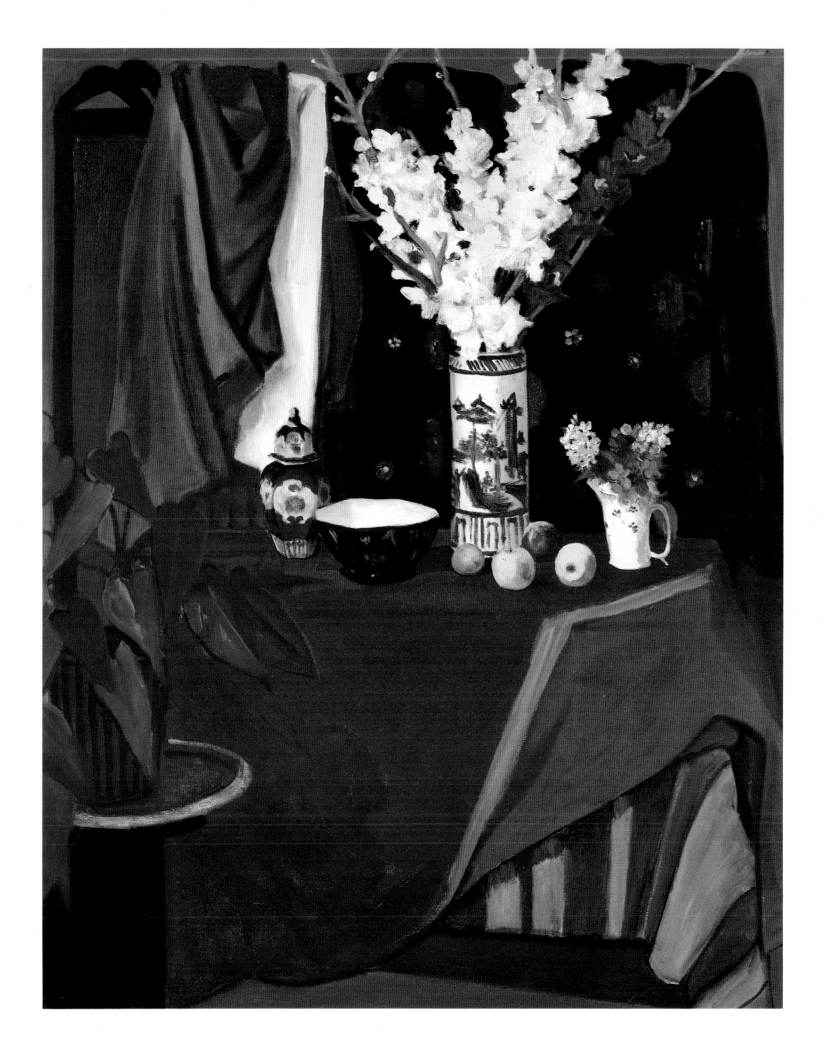

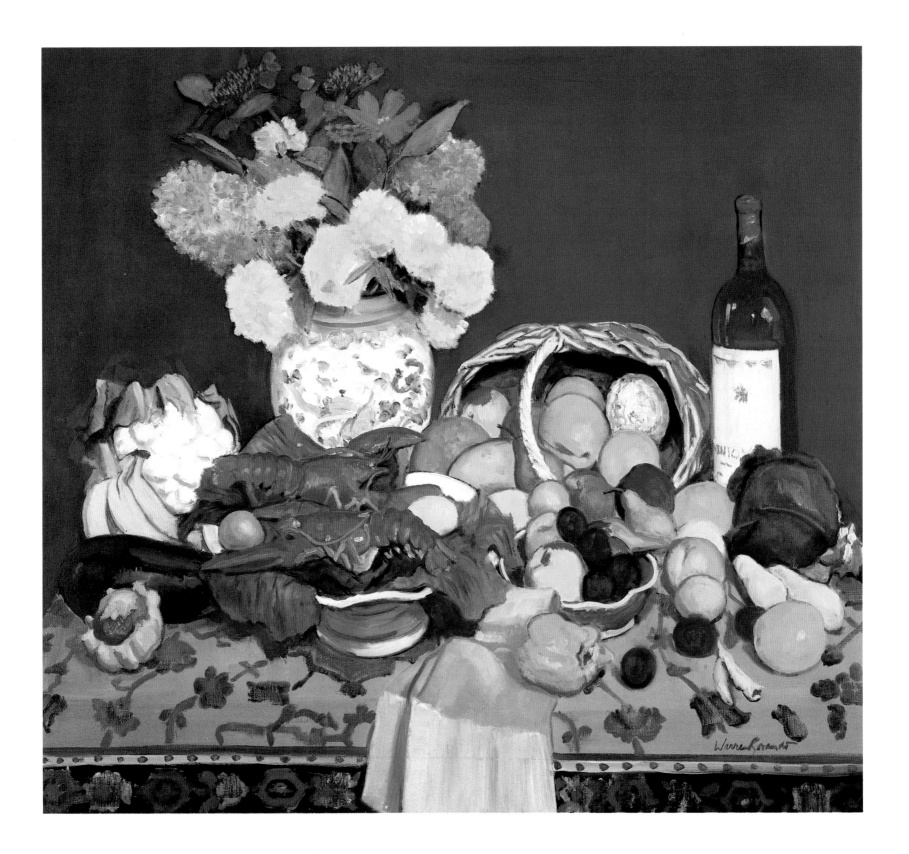

Brandt's 1985 *Still Life with Vegetables and Flowers* (page 96) was intended to be the basis of a poster for a friend's vegetable stand in East Hampton. This bit of background is characteristic—a nice friend, a beautiful place, nature's bounty. It's a gorgeous painting, and a haunting one.

The fruit cascades toward us. We feel confronted, almost attacked, by it much as we do before the still lifes of Cézanne. This art shirks nothing; it makes the subject as immediate as possible. The genuine drama of objects is in full force. Melodrama, on the other hand, is nonexistent. It is the food itself, the flowers and the bottle—not their interpretation—that grabs us.

The painting shows Warren Brandt's particular opulence at its peak. Provided with so much wonderful food by the owner of the vegetable stand, he still had to add flowers and the shawl and the wine bottle. If he is an heir to Cézanne in the overall foreshortening, in the tracery of the basket he descends from Velázquez. In the big rhythms of the composition and the constant movement through objects he reflects the lessons of many masters of many eras. What concerns him is a far cry from the latest caprice; it is, rather, the sort of visual action that has preoccupied serious artists for centuries. The way that the objects really sit there

Still Life with Vegetables and Flowers
1985
oil on canvas
34½ x 38¼ inches
Collection: Mark and Angel Joseph,
London, England

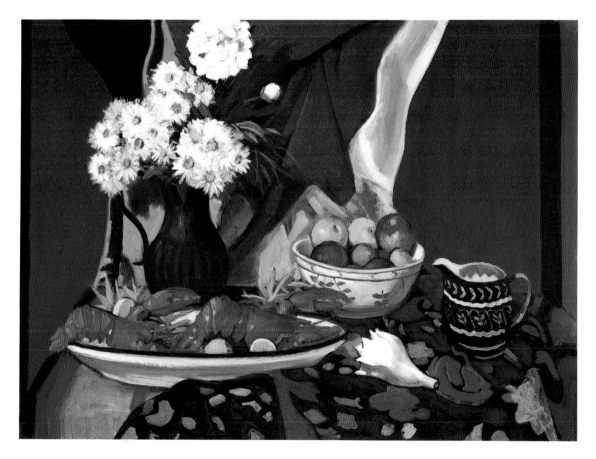

Lobster and White Daisies
1986
oil on canvas
29 × 40 inches
Private collection, Milwaukee, Wis.
Courtesy: David Barnett Gallery,
Milwaukee, Wis.

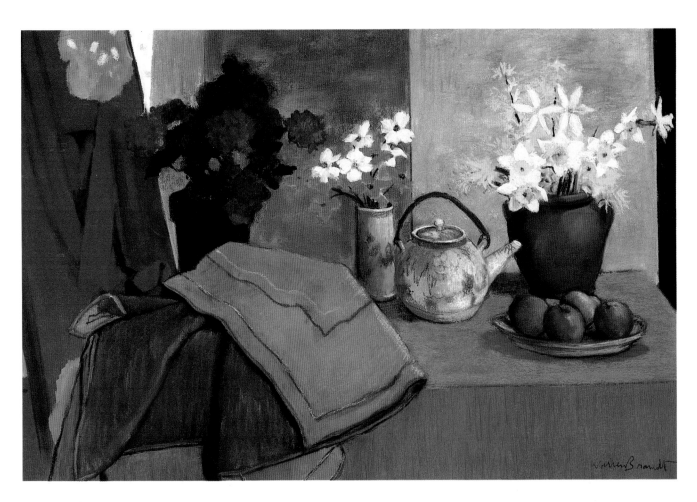

Spring Flowers and Red Robes
1986
pastel
33½ x 49 inches
Collection: Tambrands, Inc., Lake
Success, N.Y.

indicates Brandt's grasp of his craft. *Still Life with Vegetables and Flowers* is about the beauty of things and the beauty of art at the same time.

The painting refreshes us. Whatever the struggles were that went into it, it looks as if it came rather easily, and came right. The bright colors, essential to Brandt's sensibility as we now know it, enhance the sense of plenitude. Everything is bathed in an even, warm light.

The experience of looking, of apprehending physical realities, is elaborate here. We proceed from the reflection in the wine bottle to the realization of the precise form and weight of the bottle's convex shoulders. We can practically measure the thickness of its green glass and grasp its opacity. We feel as if our fingers could touch the cold metal of the band around the neck of the bottle.

The shape of the yellow gourd in the lower left of the painting is a fine thing to look at and a perfect description of the object represented. The cauliflower is that vegetable at its optimum: full, firm, and unblemished, its leaves still crisp. A lobster must be a very difficult thing to paint, but here is a rendering by someone who studied de Heem and Snyders and knows just what he is doing. On close examination, the yellow pepper in the right foreground has diverse yellows and oranges, a hint of red, and a couple of very light, broad dashes of blue on it. It is all measured, and immensely charming. We become suffused by Warren Brandt's well-tempered sense of pleasure in the little, great moments of earthly existence.

he self-portrait that hung at the National Academy of Design in 1985 returned to New York in 1987 after its nationwide tour as part of *The Figure in Twentieth-Century American Art*. It was back in time to be included in the inaugural installation of the Lila Acheson Wallace Wing at the Metropolitan Museum of Art.

At the Met, in the company of many of the crosscurrents of twentieth-century art, it is a powerful voice for the virtue of proven pictorial values, for the sort of warm, easy-going art that depends on hard labor for its unruffled equanimity. *The Artist in His Studio* is a reminder that there is always a place for traditional craftsmanship. Loveliness never fails to have its strength. As long as flowers, dunes, and the human visage are worth contemplating—and careful, articulate painting is respected—then work of this caliber will hold a position of honor. In its new home it offers a soothing, heartening welcome.

Nineteen eighty-six was also the year of a triumphant Warren Brandt exhibition at the Fischbach Gallery. Brandt's approach to form had become bolder than ever. There were an

Japanese Robes and Imari Vase
1986
pastel
27 x 39½ inches
Collection: Grace Brandt, New York, N.Y.

Le Rouge et Le Noir
1986
pastel
24 x 30 inches
Collection: Tambrands, Inc.,
Lake Success, N.Y.

ever-increasing clarity and simplicity to the pictures, the rich sort of distillation that is the key to so many artists' mature development.

In a self-portrait (page 101) done in his Water Mill studio, Brandt achieves a particularly secure grasp of both the subject matter and the overall rhythms. With a toned-down palette, he captures a rich and diverse experience, rendering the seeable with a real sense of exaltation. Throughout the show we see him probing new spatial configurations with rich tonalities. In a 1986 pastel called *Japanese Robes and Imari Vase* (page 99), the vase stands out in its fascinating muted tones; there is something offbeat and playful about it. Perhaps most remarkable is the 1986 still life called *Beckmann Catalogue* (page 103), its title subject an obvious reference to Brandt's engagement with the lives and works of other artists. *Beckmann Catalogue* shows a daring approach to space, in one way very much out of Matisse, in another wholly new. This is a warm and enticing painting. When we view it up close, the forms appear out of focus and slightly blurry, but at a distance they are crystal clear, which is the point. Brandt knows just what it takes to achieve that clarity. He has mastered the means of being upbeat in a way that convinces. To look at *Beckmann Catalogue* is to feel reassured. It has the strength of Brandt's finest work. These are urbane and sophisticated paintings that extol as many of the wonders of living as of the processes of art. They are luxuries grounded on imagination and intelligence in splendid combination.

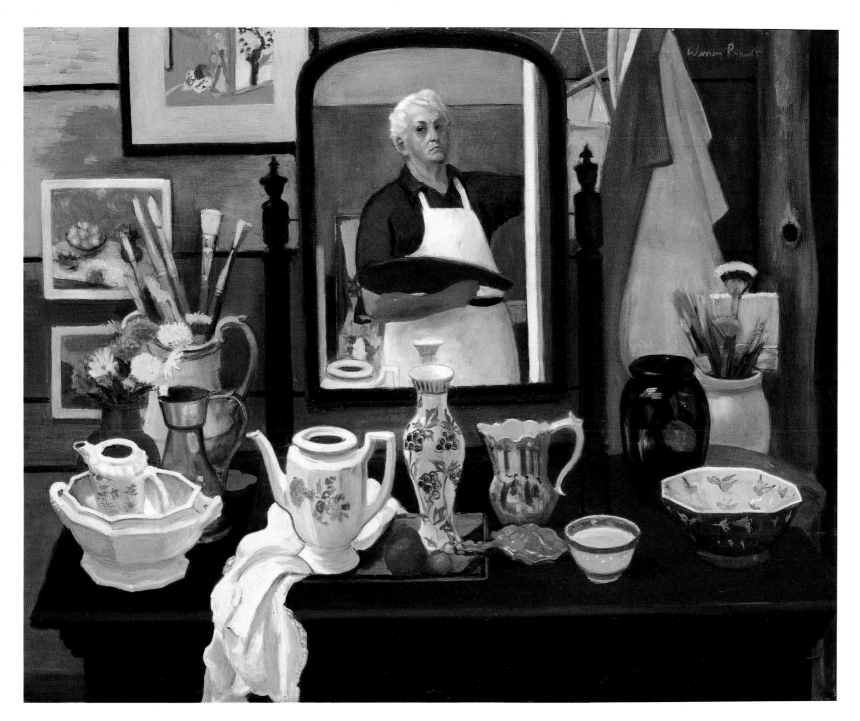

Self-Portrait, Water Mill Studio
1986
oil on canvas
40 x 50 inches
Collection: Mr. and Mrs. Daniel Rose,
New York, N.Y.

Cézanne Catalogue
1986
oil on canvas
34 x 40 inches
Collection: Mr. Joseph C. Freeman, Jr.,
Atlanta, Ga.

Beckmann Catalogue
1986
oil on canvas
40 x 54 inches

Sitting in his living room in Water Mill, surrounded by three of his still lifes done over the past fifteen years, Brandt recently said that "A good painting has got to pose some real problems— you have to work to get into it, and then you have to worm your way out. It's not necessarily pretty to begin with. It's never facile, and it doesn't always grab you at the start." He pointed out that sometimes it takes years before a painting grows on its viewers. But once a worthwhile painting has a real impact, its power remains.

He recalled an observation Matisse once made about a tired businessman looking at art. Brandt feels we have to be careful not to underestimate the idea of the role of paintings as a diversion sufficiently engaging to take the businessman's mind off all other things. Considered as such, art is far more than a vehicle for escapism. It is balm to the soul, nourishing, profound. This indeed is the power of Warren Brandt's own work. Once we have felt its rhythms and followed its ins and outs, once we have succumbed to the inexplicable mysteries of its best examples, we are held and succored by it.

White Gladioli, White Peonies
1986
oil on canvas
50 x 38 inches
Collection: Mr. Peter May, New York, N.Y.

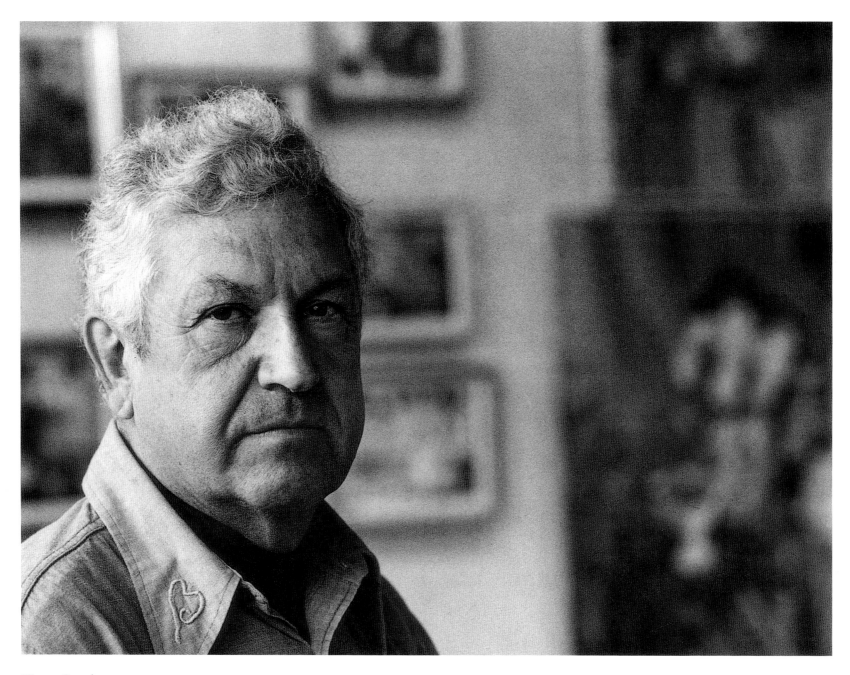

Warren Brandt, 1974

Appendix

From *Painting with Oils* by Warren Brandt

From "1. A Philosophy of Painting"

I believe that art is an extension of nature, that art is form and so are life and nature. The complex system of relationships that make up one, make up the rest. Because of this, painting is not so much a reflection of nature as it is a continuation of nature. An artist must inject his own pulse beat into his work so that it becomes completely organic. Art must carry on the life process. . . .

There is so much confusion in the art world at the present time that the wise artist is one who feels obligated to himself to do what he likes, can, and wants to do. Fashions and fads are becoming less important. Everyone is free to follow his own direction and this has been a healthy thing for the art community. . . .

The style of presentation may change, but the goal remains the same. The goal is the creation of a unified, exciting painting. . . .

The true artist is never satisfied and through his constant exploration of the world, his work must change.

After many years of painting, I have distilled what is important to me in life and in art—my family, lovely objects, a quiet life. These things I paint—in the most traditional of all media—but they are a unique expression of my vision of reality. . . .

There is a reaction to the easy, flamboyant, attention-getting art of today and this reaction is leading younger artists back into more formal—and in my opinion—more serious areas of study. . . .

In the final analysis, every artist must find his own way, his own style, his own manner of approaching the creative process. . . .

In short, don't be afraid to attempt impossibilities.

From "2. Drawing"

Although there has been a tendency to deemphasize drawing, it seems to me to be an absolute prerequisite to painting. To artists the word means organization of ideas in a linear and plastic sense. . . .

Great drawings, like the kernels of great ideas, are plastic in the sense that they allow and create movement. They not only show structure, but they

also suggest how objects can bring life to space. . . .

There is no art in simply copying something exactly as you see it in real life. A camera can perform that function much better than any painter. The artist must "interpret" what he sees and present his audience with his own special vision of the object in question. . . .

In using drawing as a beginning for a painting, put down something that you see until you begin to find an idea. The process itself will often suggest directions if you simply let your mind remain uncluttered. Soon, something will suggest a certain rhythm or order—which line should be emphasized, softened, left opened, enclosed—so that an interlocking of shapes, planes, masses, spaces, and lines takes place and the picture begins to take on that plastic sense. You will soon realize that there is more than one way to begin. . . .

A good drawing or painting will always have balancing elements which hold together as a unit, for without them, there is no drama.

From "3. Organization of Pictorial Space"

It is the artist's feelings about the world and his personal experiences that are the motivation and energy source of his paintings. A vase of flowers near a bowl of fruit may evoke an aesthetic excitement because of their relationship to each other in space. This relationship starts the form-making machinery. . . .

The artist uses all the contrasts available to him in the making of a picture. We use warm against cool colors, dark against light; we use soft shapes against hard edges, smooth surfaces against rougher ones, line against volume. . . .

More than anything, contrasts create tensions that bring excitement to a picture. Forms push out and pull back depending upon emphasis, tone, and color. Pure symmetrical balance can be a deadly thing in painting. Great pictures are achieved when their elements are dangerously and precariously balanced. . . .

As you paint, allow yourself to be open to what happens on the canvas and remain free to move

outside of the objects you are painting by allowing the contrasts and movement to assume control of the design. . . .

Things happen on the canvas for those who are flexible. . . .

Organizing space on a canvas is the most intuitive of all the elements involved in making a picture. No one can tell you how to do it in a way that will be uniquely yours. . . .

The finished picture must be . . . a living, breathing, moving thing.

From "4. Color"

There are no hard and fast rules about color. . . .

Excitement is brought about through contrasts, tone, harmony, and disharmony. . . .

I have found that all colors go together, can be held together, and can be made interesting by weighing their proper substance and value. . . .

A series of realistic objects unrelated to each other in terms of line, color, shape, mood, and light do not make a painting. . . .

Every picture must exist as a unified whole.

From "5. How to Begin a Painting"

It is just as possible to explain exactly a color relationship as it is to explain the nuances of a human relationship. . . .

The slightest change of one part means that the whole will have to be changed.

From "6. Finishing the Painting"

When finished, the picture has an existence of its own. It is neither the artist nor a reflection of him; it is a separate form that exists within and outside of time. . . .

If the artist establishes within the picture an essentially lifelike relationship and if the picture is a complete entity, then the spectator can enter it.

It is important to be able to deny your intellectual concepts of what would be right in order to use your intuition as a painter. . . .

Feeling is all important. . . .

In my work, I try not to change the subject, only

my approach to the subject. My problem is, most often, the adjustment of colors and shapes until they fit each other, not the subject. . . .

You must depend largely upon intuition. But, you must also have all the training and knowledge of your medium that you can acquire. This, and only this, allows you to pull it off. . . .

A good artist is seldom, if ever, totally satisfied with his work. The process of change and experimentation is a constant one as, trying to find the right way, he moves into new forms and back to old ones. . . .

Always welcome the process of change and, since there is no one right answer, continue to search.

From "8. Figure Painting"

If you paint the model too realistically or too beautifully or with too much individuality, the work becomes mere portraiture and loses that element of universality that marks true art. . . .

The figure must flow and fit and stay in its proper place in the space you create around it. . . .

The model becomes timeless when the artist has made her an integral part of the painting. She is no longer a woman, but an element that fits with every other element that makes that strange and mysterious thing called a work of art. . . .

Mystery in painting is a powerful force. Personally, I don't want to tell a whole story. I want a general mood that springs from the joyous and proper combination of all the elements.

From "9. Portraiture"

The main thing to bear in mind when painting portraits is that *your* painting has to be more important than a mere likeness. Like a good figure painting, it has to be a work of art first and a resemblance second. . . .

The buildup method, derived from Titian, involves working fairly dry in the beginning, letting that stage dry, scumbling and glazing as you proceed, painting into the scumbles and glazes each day but letting each layer dry and then proceeding in a slow building manner until the painting is finished. In general, this is the way I work. Colors can be made rich and full and harmonious through this method and it allows for a more reasoned approach.

From "10. Style"

When the artist approaches his painting intellectually, putting ideas ahead of emotion, trusting intellect over intuition, his paintings lose their validity. . . .

Ideas should be generated out of paintings, not put into paintings. . . .

A work of art is a measure of space, and it is form. As organized relationships between shaped areas in space, it makes its own order: form. . . .

Style can't be sought by the artist. It must come of itself. The artist aims for it only in that he works always toward wholeness. . . .

The artist . . . welcomes change because he knows life is in constant motion. He believes paintings are to be looked at and enjoyed rather than talked about.

From "11. Materials and Media"

Painting should be done . . . in a state that is somewhere between liquid and solid. This is one reason oil paint is such a marvelous medium. Through the use of this contrast of wetness and dryness, forms can be built up that have the solidity and movement and color of life. . . .

In order to be able to improvise and do what you want to do with painting, you must know the craft thoroughly. . . .

Technique itself is relatively unimportant, except that through working a system is developed which better facilitates clear expression. Whatever the choice of medium, that artist should use the technique which limits his expressions least.

Selected Public Collections

Beaumont Art Museum, Beaumont, Tex.
Chase Manhattan Bank of North America, New York, N.Y.
The Chrysler Museum, Norfolk, Va.
Ciba-Geigy Corporation, Ardsley, N.Y.
Commerce Bancshares, Kansas City, Mo.
The Currier Gallery of Art, Manchester, N.H.
Guild Hall, East Hampton, N.Y.
H. J. Heinz Corporation, Pittsburgh, Pa.
The Hirshhorn Museum and Sculpture Garden, Washington, D.C.

Archer M. Huntington Art Gallery, University of Texas, Austin, Tex.
The Lannan Foundation, Lake Worth, Fla.
Memorial Art Gallery, University of Rochester, Rochester, N.Y.
The Metropolitan Museum of Art, New York, N.Y.
Museum of Art, Carnegie Institute, Pittsburgh, Pa.
National Academy of Design, New York, N.Y.
The National Museum of American Art, Washington, D.C.

Paul, Weiss, Rifkind, Wharton & Garrison, New York, N.Y.
R.C.A. American Communications, Inc., Princeton, N.J.
Tambrands, Inc., Lake Success, N.Y.
Washington Museum of Modern Art, Washington, D.C.
Weatherspoon Art Gallery, University of North Carolina, Greensboro, N.C.
The Westland Agency, Latrobe, Pa.

Warren Brandt, 1958

One-Man Exhibitions

1959 The Nonagon Gallery, New York, N.Y.

1960 *Warren Brandt*, New Gallery, Provincetown, Mass.

1961 *Warren Brandt*, Michigan State University, Oakland, Mich.

Warren Brandt, American Gallery, New York, N.Y.

1962 *Warren Brandt: Recent Paintings*, Stuttman Gallery, Provincetown, Mass.

1963 *Warren Brandt: The Art of Collage*, Obelisk Gallery, Washington, D.C.

1964 *Warren Brandt*, Grippi & Waddell, New York, N.Y.

1966 *Warren Brandt: Recent Paintings*, A. M. Sachs Gallery, New York, N.Y.

1967 *Warren Brandt: Recent Paintings*, A. M. Sachs Gallery, New York, N.Y.

Paintings by Warren Brandt, Weatherspoon Art Gallery, University of North Carolina, Greensboro, N.C.

Warren Brandt, Eyraud-Barnes Galleries, Los Angeles, Calif.

1968 *Warren Brandt: Paintings & Drawings*, Paul Sargent Gallery of Art, Eastern Illinois University, Charleston, Ill.

Warren Brandt, Cord Gallery, Southampton, N.Y.

Warren Brandt, Reed College, Portland, Oreg.

Warren Brandt, Salem College, Salem, N.C.

1969 *Warren Brandt*, Allentown Art Museum, Allentown, Pa. Catalogue with essay by Walter Barker.

Warren Brandt: Recent Paintings, Grand Avenue Galleries, Milwaukee, Wis.

Warren Brandt, Mercury Gallery, London, England.

Warren Brandt: Paintings and Drawings, Agra Gallery, Washington, D.C.

1970 *Warren Brandt: Recent Paintings*, A. M. Sachs Gallery, New York, N.Y.

Warren Brandt: Recent Paintings, Fontana Gallery, Narberth, Pa.

Warren Brandt, Agra Gallery, Washington, D.C.

1971 *New York Painter Warren Brandt: Recent Oil Paintings*, David Barnett Gallery, Milwaukee, Wis.

Warren Brandt: Retrospective, Paul Sargent Gallery of Art, Eastern Illinois University, Charleston, Ill.

Warren Brandt, Hooks-Epstein Galleries, Houston, Tex.

Warren Brandt, Agra Gallery, Palm Beach, Fla.

1972 *Warren Brandt*, A. M. Sachs Gallery, New York, N.Y.

1973 *Warren Brandt: Still Life Paintings*, A. M. Sachs Gallery, New York, N.Y.

Warren Brandt, Hooks-Epstein Galleries, Houston, Tex.

1974 *Paintings by Warren Brandt*, The Rentschler Gallery, Grand Rapids, Mich.

Warren Brandt, Fontana Gallery, Narberth, Pa.

Warren Brandt, David Barnett Gallery, Milwaukee, Wis.

1974–75 *Warren Brandt: Paintings*, A. M. Sachs Gallery, New York, N.Y.

1976 *Paintings and Drawings by Warren Brandt*, Beaumont Art Museum, Beaumont, Tex.

Warren Brandt, Elaine Benson Gallery, Bridgehampton, N.Y.

1977 *Warren Brandt: Paintings, Drawings and Watercolors*, Hooks-Epstein Galleries, Houston, Tex.

Warren Brandt, Vick, Klaus, Rosen Gallery, Philadelphia, Pa.

Warren Brandt, North Carolina Art Society's Collectors Gallery, North Carolina Museum of Art, Raleigh, N.C.

Warren Brandt, Fischbach Gallery, New York, N.Y.

1978 *Warren Brandt*, David Barnett Gallery, Milwaukee, Wis.

Warren Brandt, Allen House Gallery, Louisville, Ky.

Warren Brandt, Fontana Gallery, Narberth, Pa.

1979 *New York Painter Warren Brandt: Recent Paintings and Works on Paper*, Fontana Gallery, Narberth, Pa.

1980 *Warren Brandt*, Fischbach Gallery, New York, N.Y.

Warren Brandt: Recent Paintings, Bergsma Gallery, Grand Rapids, Mich.

1981 *Warren Brandt: Recent Oil Paintings from Cocoyoc, Mexico*, David Barnett Gallery, Milwaukee, Wis.

1982 *Warren Brandt*, Greenhill Gallery, Greensboro, N.C.

1983 *Warren Brandt: Paintings and Pastels*, Phoenix II, Washington, D.C.

Warren Brandt: Recent Paintings, David Barnett Gallery, Milwaukee, Wis.

Warren Brandt: Recent Paintings, Fischbach Gallery, New York, N.Y. Catalogue with essay by Irwin Shaw.

1985 *Warren Brandt*, Fischbach Gallery, New York, N.Y.

1986 *Nudes by Warren Brandt*, Metropolitan Museum of Art, Mezzanine Gallery, New York, N.Y. Prints, monotypes, and limited-edition book *Nudes*.

Warren Brandt, Fischbach Gallery, New York, N.Y.

Group Exhibitions

II, Elaine Benson Gallery, Bridgehampton, N.Y.

1984 *Warren Brandt, Robert Dash, Syd Solomon, Calvin Albert*, Bologna-Landi Gallery, East Hampton, N.Y.

Warren Brandt, Mort Ostrer, William Pellicone, Marie Pellicone Gallery, Southampton, N.Y.

The Hampton Scene: Then and Now, Alex Rosenberg Gallery/Transworld Art, New York, N.Y.

Five Students of Max Beckmann, Bixby Gallery, Washington University School of Fine Arts, St. Louis, Mo. Catalogue.

The Garden, Kornbluth Gallery, Fair Lawn, N.J.

Six Artists Inspired by the Poems of Robert Graves, Sneed Gallery, Rockford, Ill.

1985 *Flowers by Seven Realist Painters*, presented by the Prudential and the Mendik Company, organized by Modern Art Consultants, New York, N.Y.

Warren Brandt, A. J. Cava, Jane Freilicher, Joe Hazan, Polly Kraft, Jim Touchton and Jane Wilson, Tower Gallery, Southampton, N.Y., in conjunction with Fischbach Gallery.

American Realism, William Sawyer Gallery, Southampton, N.Y.

Warren Brandt, Giglio Dante, Berenice D'Vorzon, Arnold Hoffmann, Jr., Bologna-Landi Gallery, East Hampton, N.Y.

Eldindean Press XVII by XVII 1985, a

Portfolio of 17 Miniature Intaglio Prints, Sylvan Cole Gallery, New York, N.Y.

1985–86 *The Figure in Twentieth-Century American Art: Selections from the Metropolitan Museum of Art*, organized by the Metropolitan Museum of Art and the American Federation of Arts: Jacksonville Art Museum, Fla.; Oklahoma Museum of Art, Oklahoma City, Okla.; National Academy of Design, New York, N.Y.; Terra Museum of American Art, Evanston, Ill.; Arkansas Arts Center, Little Rock, Ark.; Colorado Springs Fine Arts Center, Colorado Springs, Colo.; Minnesota Museum of Art, St. Paul, Minn. Catalogue.

Figural Art of the New York School: Selections from the Ciba-Geigy Collection, Baruch College Gallery, New York, N.Y. Catalogue with essay by Katherine B. Crum.

The East Hampton Star 100th Anniversary Portfolio: Works by 52 Contemporary Artists of the Region, Guild Hall, East Hampton, N.Y.

Survival of the Fittest II: Figurative Works on Paper, Ingber Gallery, New York, N.Y.

1986 *Arrangements in Color and Shape: Still Lifes*, C. Grimaldis Gallery, Baltimore, Md.

Born in North Carolina, Gerald Malberg Gallery, Charlotte, N.C.

The Art of the Classical Watercolor, Elaine Benson Gallery, Bridgehampton, N.Y.

Summer Issue, Fischbach Gallery, New York, N.Y.

The Object Revitalized, Paine Art Center and Arboretum, Oshkosh, Wis.; Muscatine Art Center, Muscatine, Iowa.

Four Artists, Bologna-Landi Gallery, East Hampton, N.Y.

East End Artists at the Gristmill, Water Mill Museum, Water Mill, N.Y.

Landscape, Seascape, Cityscape, Contemporary Art Center, New Orleans, La.; New York Academy of Art, New York, N.Y. Curated by Alexandra Monett, catalogue essay by Alexandra Monett.

Masterworks by Nineteenth- and Twentieth-Century Photographers, Janet Lehr, Inc. for Vered Gallery, East Hampton, N.Y.

National Academy of Design, 161st Annual Exhibition, New York, N.Y.

The Food Show, Nabisco Gallery, East Hanover, N.J.

Thirty-Six Artists, Benton Gallery, Southampton, N.Y.

1987 *Lila Acheson Wallace Wing for Twentieth-Century Art*, Metropolitan Museum, New York, N.Y.

The Hamptons in Winter, Gallery International 52, New York, N.Y.

Farm to Hearth, Bronx Museum of the Arts, Bronx, N.Y.

National Academy of Design, 162nd Annual Exhibition, New York, N.Y.

Summer Group Show, Vered Gallery, East Hampton, N.Y.

Bibliography

One-Man Exhibitions

Adlow, Dorothy. "Brandt Pictures on Exhibition." *Christian Science Monitor*, Apr. 27, 1963.

Art International. "Warren Brandt." vol. XVI/6, Summer 1972.

Artnews. "Warren Brandt." Apr. 1966.

Arts. "Warren Brandt." Apr. 1968.

———. "Warren Brandt." May–June 1973.

Art/World. "Warren Brandt." Nov. 12–Dec. 9, 1977.

Auer, James. "The Colorful Brandt." *The Milwaukee Journal*, Mar. 2, 1980.

Barker, Walter. "Weatherspoon Art Gallery Will Display Brandt Works." *Greensboro Daily News*, Apr. 15, 1967.

———. "Warren Brandt: Coherent and Satisfying." *Art/Scene/Milwaukee*, May 1969.

Beaumont Journal. "Art and Education Team Up at Museum." Sept. 27, 1976.

Canaday, John. "Art: Like the Stumpy Crocus, Rather Encouraging." *The New York Times*, Apr. 2, 1966.

———. "Warren Brandt." *The New York Times*, March, 1967.

Cherry, Herman. "Brandt: The Mystery of the Commonplace." *Artnews*, vol. 67, no. 1, Mar. 1968, p.38.

Dalphonse, Sherri. "A Still life with Movement— Painter Warren Brandt Feels That a Canvas Should Be a Movable Feast." *Hamptons Newspaper/Magazine*, Aug. 16, 1984.

Derfner, Phyllis. "New York Letter." *Art International*, vol. XIX/2, Feb. 20, 1974.

Donohoe, Victoria. "Warren Brandt: He's a Colorist, Pure and Simple." *The Philadelphia Inquirer*, June 1979.

East Hampton Star. "From the Studio" (review of Fischbach Gallery exhibition). Dec. 1986.

Forgey, Benjamin. "Art: Brandt, an Artist Who Gets Away with Rendering." *Washington Star*, Nov. 29, 1970.

France-Amérique. Le Courrier des Etats-Unis. "Warren Brandt." Apr. 7, 1966.

Frank, Peter. "Matisse/Cézanne Sides of Warren Brandt." *St. Louis Post-Dispatch*, Jan. 12, 1975.

———. "Warren Brandt." *The Village Voice*, Dec. 5, 1977.

Freed, Eleanor. "Brandt, a Modern Day Intimist." *Houston Post*, Nov. 7, 1971.

Getlein, Frank. "Two New Art Exhibitions Show Human Figure Use." *Washington Star*, Apr. 20, 1969.

Greensboro Daily News. "Tar Heel Heads Art Dept." Oct. 14, 1957.

———. "Warren Brandt: Giant Man-Artist." Mar. 17, 1974.

Henry, Gerrit. "Warren Brandt at Fischbach." *Art in America*, Mar. 1987.

Hunnewell, Richard F. "Brandt, Pitts, Fish, Mondrian." *Art/World*, Feb. 1985.

Jensen, Dean. "His Palette Gleams with Fresh Paint." *Milwaukee Sentinel*, Feb. 1, 1980.

Jones, Abe D., Jr. "Exhibition at the Met Includes Greensboro Artist's Portrait." *Greensboro News & Record*, Mar. 21, 1982.

———. "Tar Heels Come Home for Exhibit." *Greensboro News & Record*, Sept. 16, 1982.

Key, Donald. "Bright Oils by New York Artist Make Delightful Debut Here." *The Milwaukee Journal*, May 18, 1969.

Kramer, Hilton. "Warren Brandt." *The New York Times*, May 16, 1980.

Krebs, Patricia. "Brandt: Artist Who Fought It Out." *Greensboro Daily News*, Nov. 2, 1975.

LeSuer, Claude. "Warren Brandt: A New Life for Still Life." *Artspeak*, vol. VI, no. 10, Feb. 1, 1985.

Lewis, Jo Ann. "Oases from Routine." *Washington Post*, Feb. 1983.

Lewis, Owen. "Warren Brandt." *Greensboro Daily News*, April 1968.

Mancewicz, Bernice. "Art Exhibit by Brandt at Bergsma Is Dazzling." *The Grand Rapids Press*, Oct.–Nov. 1980.

Mikotajuk, Andrea. "Warren Brandt." *Arts Magazine*, Dec. 1974.

The Milwaukee Journal, "Brandt's Color Brightens." Apr. 25, 1971.

———. "Brandt Homage to French Masters." May 5, 1974.

———. "Canvassing the Local Galleries." May 7, 1978.

Morris, Willie. "My View: Willie Morris." *Newsday*, July 1975.

Moser, Charlotte. "Warren Brandt: Painter of the Timeless Moment." *Southwest Art Gallery Magazine*, Nov./Dec. 1971.

New Beacon (Provincetown, Mass.). "Painting by Warren Brandt at Stuttman Gallery." Aug. 1962, p. 3.

New York Herald Tribune. "Art Tour." Apr. 2, 1966.

The New York Times. "Summary of Gallery Shows." Mar. 16, 1968.

Pellicone, William. "The Figurative Side of the Coin." *Artspeak*, vol. II, no. 1, May 1980.

The Philadelphia Inquirer. "Brandt Blends Colors, Animation and Love." June 21, 1970.

Sawyer, Kenneth. "Notes on the Painter Warren Brandt." *Art International*, vol. X/3, Mar. 20, 1966.

Seltz, Johanna. "Artist Rearranges Life for Painting." *News & Observer* (Raleigh, N.C.), May 1, 1977.

Slivka, Rose C. S. "From the Studio—'Nudes.'" *East Hampton Star*, Feb. 19, 1987.

Smith, June. "Brandt's Direct Art to Be Shown." *Beaumont Journal*, Sept. 24, 1976.

Time. "Warren Brandt." vol. 87, no. 15, Apr. 15, 1966.

Willard, Charlotte. "Warren Brandt." *New York Post*, Mar. 16, 1968.

Wykes-Joyce, Max. "Pictures on Exhibit." *London News and Views*, vol. XXXIII, no. 1, Oct. 1969.

Group Exhibitions

Ashton, Dore. "Pastel Anthology." *Arts*, Feb. 1966.

Arts. "The Hamptons Scene: Then and Now." Dec. 1984.

Barker, Walter. "Ex-St. Louisans' Art Shown in New York." *St. Louis Post-Dispatch*, Apr. 10, 1966.

Braff, Phyllis. "From the Studio." *East Hampton Star*, June 7, 1984.

Commercial Appeal (Memphis, Tenn.). "Memphis Academy Group Will Have Reception." Jan. 13, 1959.

Donohoe, Victoria. "Exhibit by Two Dissimilar Artists Shows Strong Visual Foundation." *The Philadelphia Inquirer*, May 13, 1977.

Forgey, Benjamin. "Fresh Life for the Old Tradition." *Washington Star*, Mar. 21, 1980.

G Magazine (Greensboro, N.C.). "Oriental Vases and Japanese Print." Oct./Nov. 1982.

Goddard, Denny. *Corpus Christi Times*, Apr. 15, 1983.

Gruen, John. "Paintings of Childe Hassam Fund Go on Exhibit at Academy of Arts." *New York Herald Tribune*, Feb. 5, 1965.

Hammel, Faye. "Protest on Tenth Street—Avant-Garde Painters Create Their Own Gallery World on Manhattan's East Side." *Cue*, Mar. 28, 1959.

The Hamptons Voice. "Art and Artists: Three Views." July 7, 1967.

Hooten, Bruce Duff. "Lieberman's Acquisitions." *Art/World*, Feb. 22–Mar. 22, 1982.

Kaye, George. *Pastels*. The Pitman Art Series, no. 85. New York: Pitman Publishing Corp., 1974.

The Long Island Press (Guild Hall group show in East Hampton). Jan. 11, 1976.

Lovenheim, Barbara. "Showing Hampton Art in Winter." *The New York Times*, Mar. 1, 1987.

Mancewicz, Bernice. "Owl's Nest Scene of Pleasant Art Show." *The Grand Rapids Press*, Aug. 24, 1980.

News-Times (Danbury, Conn.). Aug. 31, 1984.

New York Herald Tribune. "Pastel Anthology at Borgenicht." Jan. 29, 1966.

Paris, Jeanne. "Art Review: Viewing Central Park." *Newsday*, May 16, 1980.

Print Collector's Newsletter. "Eldindean Press XVII by XVII." Vol. XVI, no. 4, Sept./Oct. 1985.

Rosenberg, Harold. *The New Yorker*, July 15, 1972.

Rosing, Larry. "Matisse and Contemporary Art, 1970–1975." *Arts*, vol. 49, no. 9, May 1975.

Schmidt, Doris. *Max Beckmann Retrospective*. St. Louis Art Museum in association with Prestel-Verlag, Munich, 1984.

Shirey, David. "The Naked and the Nude: Not the Same Thing." *The New York Times*, May 20, 1979.

Southampton Press (Bologna-Landi Gallery group show). Aug. 22, 1985.

The Village Voice. "Lila Acheson Wallace Wing, Metropolitan Museum of Art." Feb. 3, 1987.

Index

Pages in *italics* refer to illustrations

Photograph Credits

All uncredited works are in the artist's collection.

All color photographs are by eeva-inkeri, with the exception of those on the following pages:
Lee Stalsworth: 37
Dian Wehrle: 87, 88

Black-and-white photographs are by the following:
Emanuel C. Benson: 33
Warren Brandt: 109
Dan Budnick: 42
Timothy Greenfield-Sanders: 72
Hans Namuth: 106
Burk Uzzle (© Magnum Photos, Inc.): 48
© Sarah Wells 1986: 8, 44, 56